A ROYAL ALBUM

LICHFIELD

A
ROYAL
ALBUM

DESIGNED BY CRAIG DODD

ELM TREE BOOKS · LONDON

Acknowledgements

*My grateful thanks to Grania Forbes
in association with whom I wrote the text.
And to my assistants Peter Kain and John Whyte
for all their help.*

First published in Great Britain 1982
by Elm Tree Books/Hamish Hamilton Ltd
Garden House 57–59 Long Acre London WC2E 9JZ

First published in this edition 1984

Copyright © 1982 by Patrick Lichfield

British Library Cataloguing in Publication Data
Lichfield, Patrick
A Royal album.
1. Windsor, House of 2. Great Britain—
Kings and rulers—Portraits
I. Title
941.085′5′0922 DA591.A1
ISBN 0-241-11335-0 Pbk

Typeset by Servis Filmsetting Ltd, Manchester
Printed in Italy by Arnoldo Mondadori Editore, Verona

CONTENTS

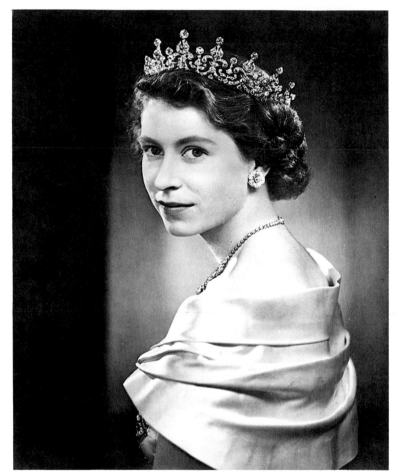

Karsh of Ottawa (1951)
The young Queen, regal and lovely, spirited and encouraging, against a background so elegantly plain as to make her stand out free from all encumbrance.

FOREWORD
TOM BLAU

How fascinating it would be if there were a portrait study of Julius Caesar by Karsh of Ottawa, of Cleopatra by Snowdon, of Queen Boadicea or of Catherine the Great by Norman Parkinson, of the Congress of Vienna or of Napolean's Empress, Josephine, by Patrick Lichfield!

Paintings and sculptures are never fully convincing; they were usually richly paid assignments and the painters and sculptors knew on which side their bread was buttered.

We are luckier today; photography can flatter but it cannot really lie altogether and as there always are many photographs of people of prominence, the public has a chance to form a pretty good idea of what men and women of consequence truly look like; and so they have, perhaps, a better key to their characters. The most coveted prize in contemporary photography in Britain is to be invited to photograph a member of the royal family. There is no way to achieve such an invitation except by being asked and the asking is done with a very remarkable degree of discernment and sensitivity.

Once you are given the opportunity, you are given the chance to reconnoitre the position and site, that is the rooms and chairs, and other furnishings, that you think will be best suited to your work. It takes a strong character and nerves of steel to be at your very best when the actual sitting occurs. You are invariably treated with charm and courtesy, and made to feel at ease but few photographers, when first invited, are able to be entirely relaxed and artistically and technically at their best.

My company, Camera Press, and I, have had the great good fortune to be allowed to handle a considerable part of royal photography over the past thirty-five years which has given me an insight into the astonishingly continuous, untiring keenness of newspapers and magazines, books and television, to publish the most recent image of a member of the royal family.

There can be little doubt that the British royal family is regarded as the royal family throughout the Western World.

Eagerness to publish, and rivalry for publishing first, is particularly keen in Germany, France and Italy – all countries with Republican constitutions. But the rules of distribution are of elegant austerity; clear, firm publication dates are set, no-one may publish prior to the appointed date and no-one can acquire exclusive first rights of publication in any photograph taken for which a member of the royal family has granted a special sitting (photographs taken in the public domain, without special facilities, are a different matter altogether).

Although the regulations are well-known everywhere, frantic attempts to persuade the distributor to break these straight, simple and obviously fair and sensible rules are almost grotesque in their frenzy. On major occasions the sums on offer for a special deal are bizarre; but they are meant in deadly earnest and no amount of pointing to the long-established order in these matters will persuade – especially some German magazines – that here cheque-book journalism is out and that photographs of Society's crème de la crème are syndicated with an even-handedness that would theoretically delight the most ardent communist.

The number of publications that occur on the release of an important new royal portrait often goes into thousands; and when the rush of publication in morning, evening and Sunday newspapers has abated, there are follow-ups in a great variety of ways; brochures of charitable companies of which a member of the royal family is the patron, menu cards, displays in boardrooms, and commercial usage of a kind strictly defined and controlled by the Lord Chamberlain, such as on dinner services, key rings, stationery, calendars. Whenever a royal visit is paid to open an institution, to honour a township, to visit a foreign country, the demand is revived; and whenever there is a turning point in the life of a member of the royal family, mainly on the occasion of marriage, photographs are brought out of files which go back to babyhood and encompass the most comprehensive re-publication of photographs taken at every stage of the life of a royal.

The engagement and subsequent marriage of Prince Charles and Lady Diana Spencer was one of the highlights in the always lively scene surrounding royal portraiture. The splendid, classically simple head studies of Lady Diana by Snowdon, first taken for Vogue, took the whole world by storm. The delight felt in the happy choice made by the heir to the throne reverberated even throughout the press beyond the Iron Curtain; and the delightful photographs by Patrick Lichfield of the wedding groups and the bridal couple made a most remarkable impact everywhere.

It would be folly to read too much social significance into the different styles of photographers who photographed the royal family over these past three or four decades; but to the historian in perhaps a hundred years' time there will be some pointers illustrating how sensibly and sensitively the royal family has adjusted itself to the changes in our times and how photography has reflected these attitudes.

Lord Lichfield, when he began his professional photographic career, appointed me his sales representative from the start, and I took some photographs of him in the early days of his work. The studio was at the same place it is today, 20 Aubrey Walk, London W8; his two colleagues were Lady Elizabeth Ramsay and Lord Encombe. Patrick was the photographer but he also helped when required in the photographic darkroom.

From the very start of his career, Patrick Lichfield had the advantage of great personal charm, quite outstanding industry and application and an inner self-assurance which is one of the major attributes of great photographers.

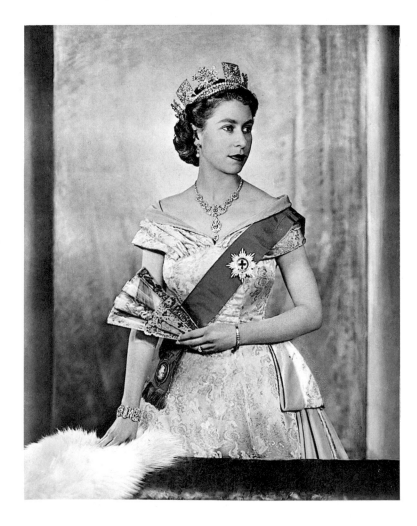

Dorothy Wilding (1952)
Here the Queen in formal, regal splendour reflects tradition, restraint and age-old conservative values.

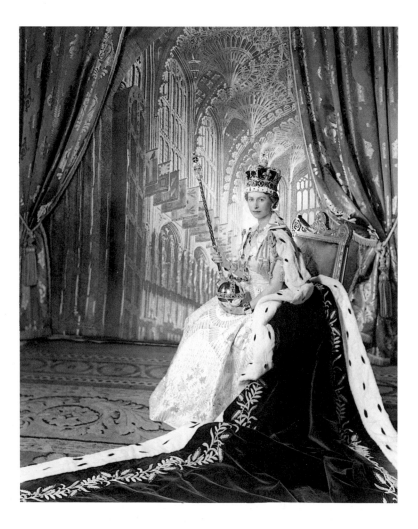

Cecil Beaton (2 June 1953)
The Queen's Coronation Day; crown, sceptre and orb, a background of stately regality. Beaton was also a most successful stage director and writer.

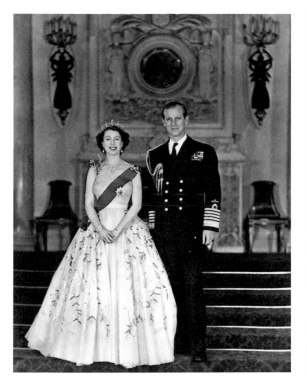

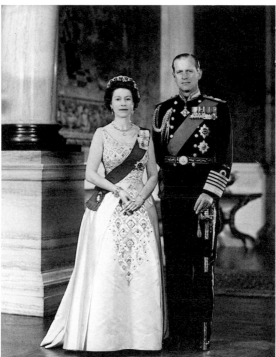

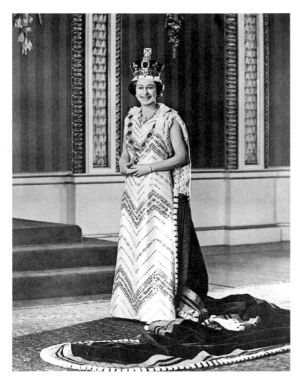

Baron (1953)
The young Queen and Duke of Edinburgh: their expression and bearing show the expectation of the Coming of a Second Elizabethan Age – high-spirited, brave and self-assured.

Anthony Buckley (1966)
The royal couple: all about them is regal, formal, slightly forbidding. The Queen's rule was in its thirteenth year.

Peter Grugeon (1977)
The choice of photographer was a remarkable departure from previous practice in that he was successful portraitist in a provincial town (Reading in Berkshire). Grugeon photographed the Queen in the Throne Room of Buckingham Palace in highly formal dress but highly informal and infectious smile.

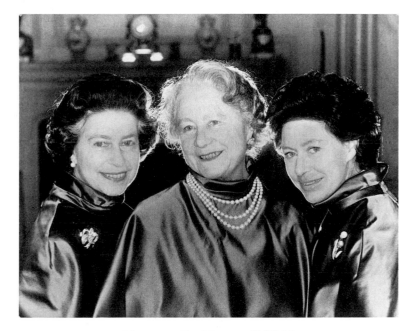

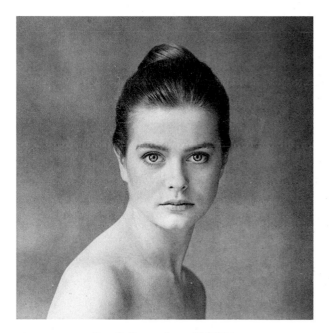

Norman Parkinson (1980)
The Queen Mother at eighty and her two daughters, the Queen and Princess Margaret, all wearing matching capelets of rich, dark blue satin. This quite extraordinary composition appeared on double pages throughout the world and showed the bold originality of Norman Parkinson, who from having been one of the world's most famous fashion photographers became additionally one of the most distinguished and enterprising portraitists of the royal family.

Lord Snowdon (1982)
This portrait study of Lady Helen Windsor, daughter of the Duke and Duchess of Kent, at the age of eighteen, was again a sensational departure from all royal photography that had gone before. The daring, stark, simplicity gives extraordinary beauty to one of the younger members of the royal family not yet frequently seen in public.

His progress was startling, on a very wide basis, and quite meteoric. From having been the assistant and apprentice of a well-known and established London photographer, Dmitri Kasterine, he set up in business on his own and he openly and sensibly used his many unique connections. One of the first photographs he took that caused sensation and widespread admiration was a group of the 'Top Twenty People in London'. Nobody but Patrick could have assembled dukes and boxers, stage stars and financiers, high-society, jockeys and jet-set luminaries peacefully in one studio and nobody could have attracted from them such instant friendly reaction as the photograph required. His zest and constantly improving photographic techniques were and continue to be unequalled and admirable. When first he appeared on television he was shy and tongue-tied; he now is witty, relaxed, remarkably knowledgeable and a much sought-after guest of honour and judge of photography – quite apart from being probably the best-dressed man within the United Kingdom and beyond. But as a photographer he has gone from strength to strength and not surprisingly takes the most delightful pictures of the most delightful women; they all seem to be delighted with him.

There is a golden touch about Patrick Lichfield's photography, and with that unbelievable and special quality found in well-bred Englishmen, he seems to keep growing and developing and further improving.

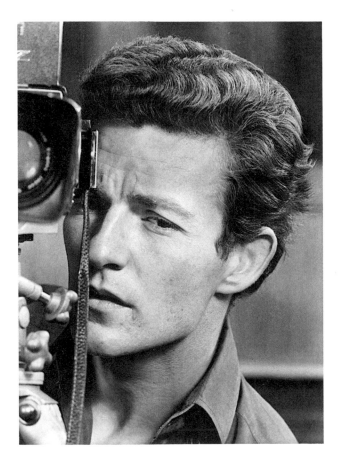

Patrick Lichfield photographed by Tom Blau.

HMY BRITANNIA

*I*n 1971 the Queen's Press Secretary Bill Heseltine telephoned me to say that the Queen needed a series of photographs for use during her Silver Wedding anniversary the following year. They were to illustrate the daily routine of her life and he asked me if I could cover a section of the far eastern tour she was about to undertake.

The trip was to be on the royal yacht Britannia. Not only was it an honour to be asked but the royal yacht is an extremely well run ship and offers an eminently comfortable and sensible way to travel so I was delighted to receive the commission and readily agreed.

We were sailing through the Indian Ocean on our way from the Seychelles to Mauritius when this photograph was taken. Although it was well after midnight, the Queen and her Private Secretary, Sir Martin Charteris, were still working. I believe they were preparing the speech which the Queen was to give at the state opening of Parliament in Mauritius the next day. The photograph illustrates, I think, their dedicated professionalism. Not many people realise just what long hours are worked by the Queen and her staff. No matter where she is in the world, the red boxes containing the papers of state are flown out for her attention and however full her foreign programme may be she has to stretch the hours of the day to deal with them. Despite the lack of detail in this high speed picture, it is just possible to see one of the red boxes at the Queen's elbow, stamped with her name.

As it was so late at night there was practically no light and this presented some photographic problems. I did not want to use a flash because I felt it would not only disturb the Queen and Sir Martin but destroy the atmospheric feeling of the picture. I decided the answer was to shoot the photograph with a tripod although this was not without risk in itself because, no matter how big the ship in which you are travelling, there is always some engine vibration which could have made the photograph blur. Happily, this time it was all right.

I have affectionate memories of Sir Martin on this trip. Now Lord Charteris, he was the Queen's Private Secretary for twenty-seven years and an enviably energetic and athletic man. Even on Britannia, where there were so many people, he was the life and soul of the party and, despite the fact that he was by no means the youngest man aboard, he nearly always beat everyone at deck quoits. In the photograph he is wearing what is known as Red Sea rig – an open-necked dress shirt with cummerbund and dress trousers – the correct evening dress in the tropics on board Britannia.

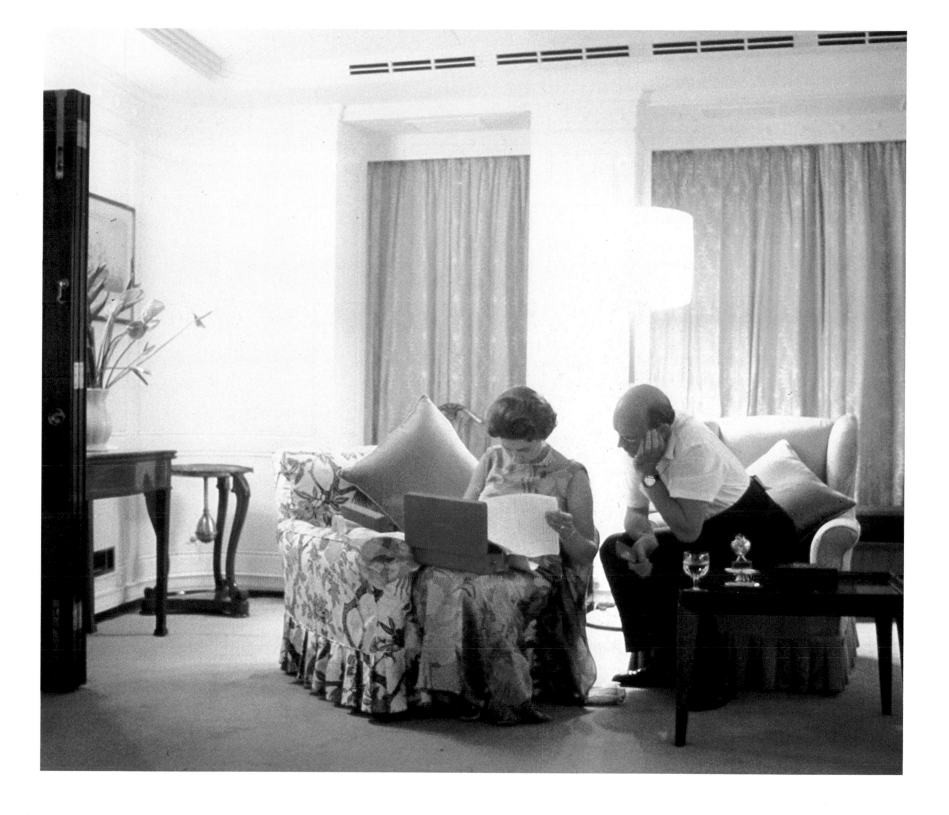

*O*ne of the most moving sights I witnessed during my stay on the yacht was the sail-past. This is when the escorting frigate, on this tour the Arethusa, and the accompanying supply vessel come alongside to salute the Queen. The two ships sail in line astern and first one moves forward alongside Britannia to the port side with the crew lined up on the deck. The sailors raise their caps and give three cheers. As soon as the Queen has acknowledged their greeting, the ship returns in line and the process is repeated by the second ship moving up alongside to starboard. Shortly after the sail-past, those of us who had not been on board before, were invited to look around the Arethusa. This involved the unnerving business of being hoisted from one ship to the other whilst both are travelling at a considerable number of knots. A memorable experience.

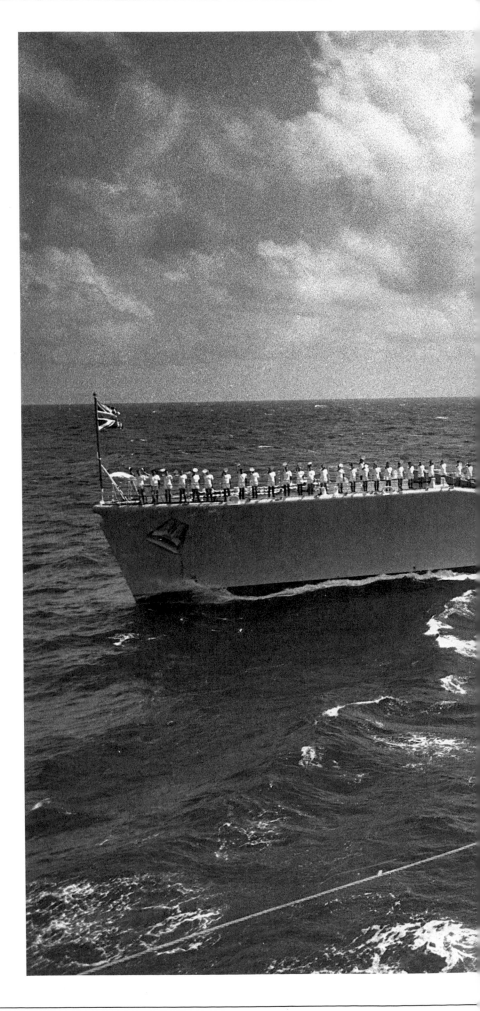

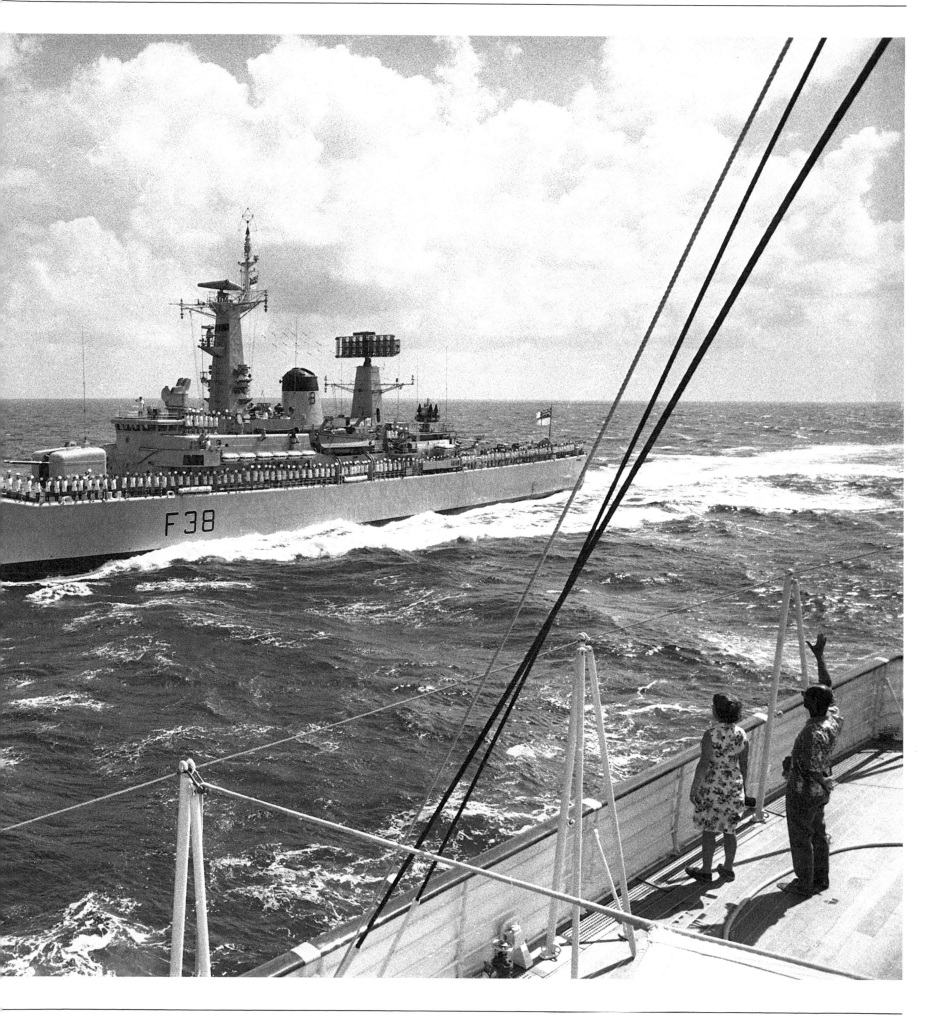

*E*qually memorable was the day we crossed the equator. I had crossed it many times before but never at sea. As we approached the line, I received my summons from Lord Plunket who said, 'I hope you've got an old suit with you because now you're for it'.

Indeed I was. The crew were all dressed up and loving every minute of my discomfiture. I was dragged out, covered in shaving soap and propelled into a makeshift pool where I was ducked several times. But I did have the wit to take a waterproof camera with me and when I came up for about the third time, I took a picture of the Queen up on the bridge laughing at me.

It's not a particularly original or well-composed shot but it does illustrate the number one photographic rule: have a camera with you at all times – even when being submerged.

The Queen must have great stamina. Late as she may get to bed the night before she is always up bright and early the next morning ready to start her busy day. I clearly remember that on the morning after I had photographed her at work with Sir Martin she was up at an early hour, in full state dress all prepared to step off the yacht and begin work. While I, somewhat bleary-eyed, was waiting at the bottom of the gangplank to photograph her.

I must admit that I felt very far from energetic by the end of that tour. It was amazing to see how the Queen could go from place to place looking immaculate and relaxed when the rest of us were on our knees with exhaustion. We were jumping on and off press buses like men possessed and we seemed to be perpetually five minutes late getting everywhere. The walkabouts in particular could be a nightmare with photographers falling over each other as they moved backwards in front of the Queen. I realised then what a difficult and hazardous life it was for a photographer assigned to that sort of job. It was bad enough for me and I did not have to keep wiring pictures back to London.

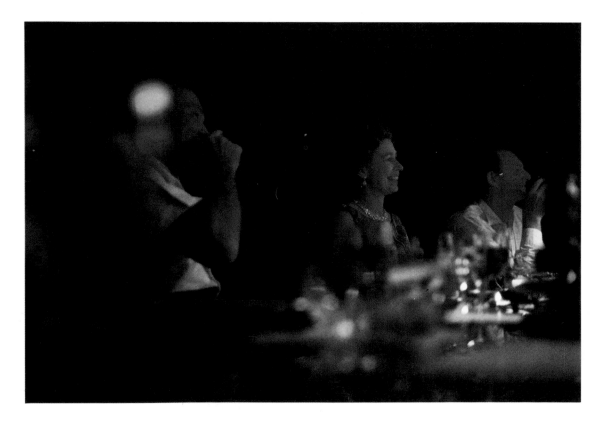

The Queen at dinner aboard Britannia

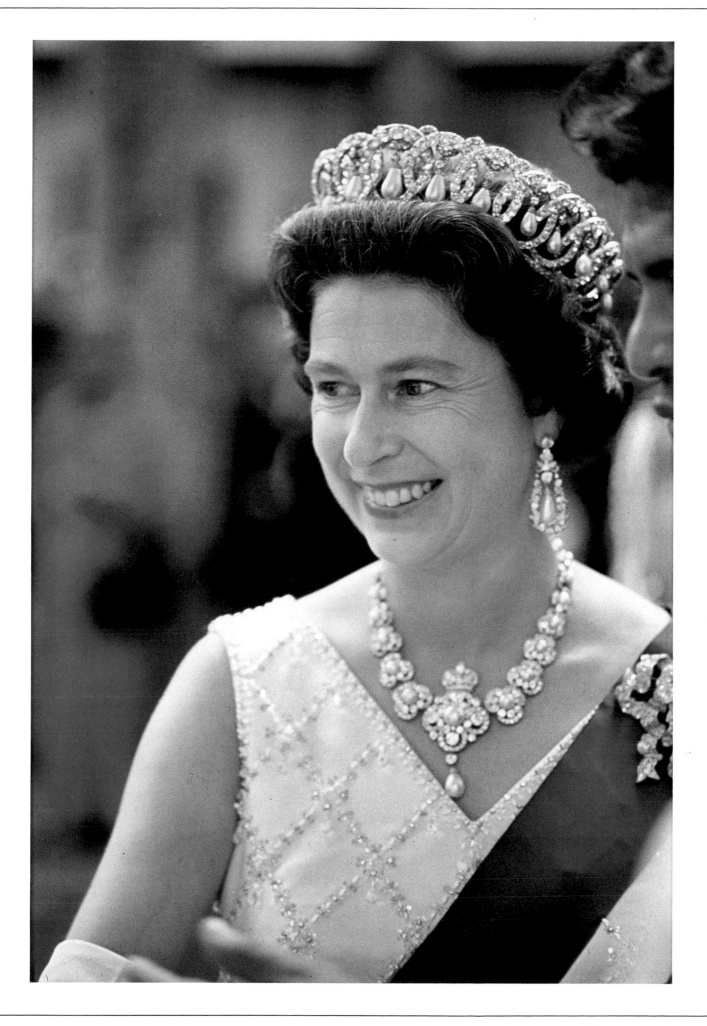

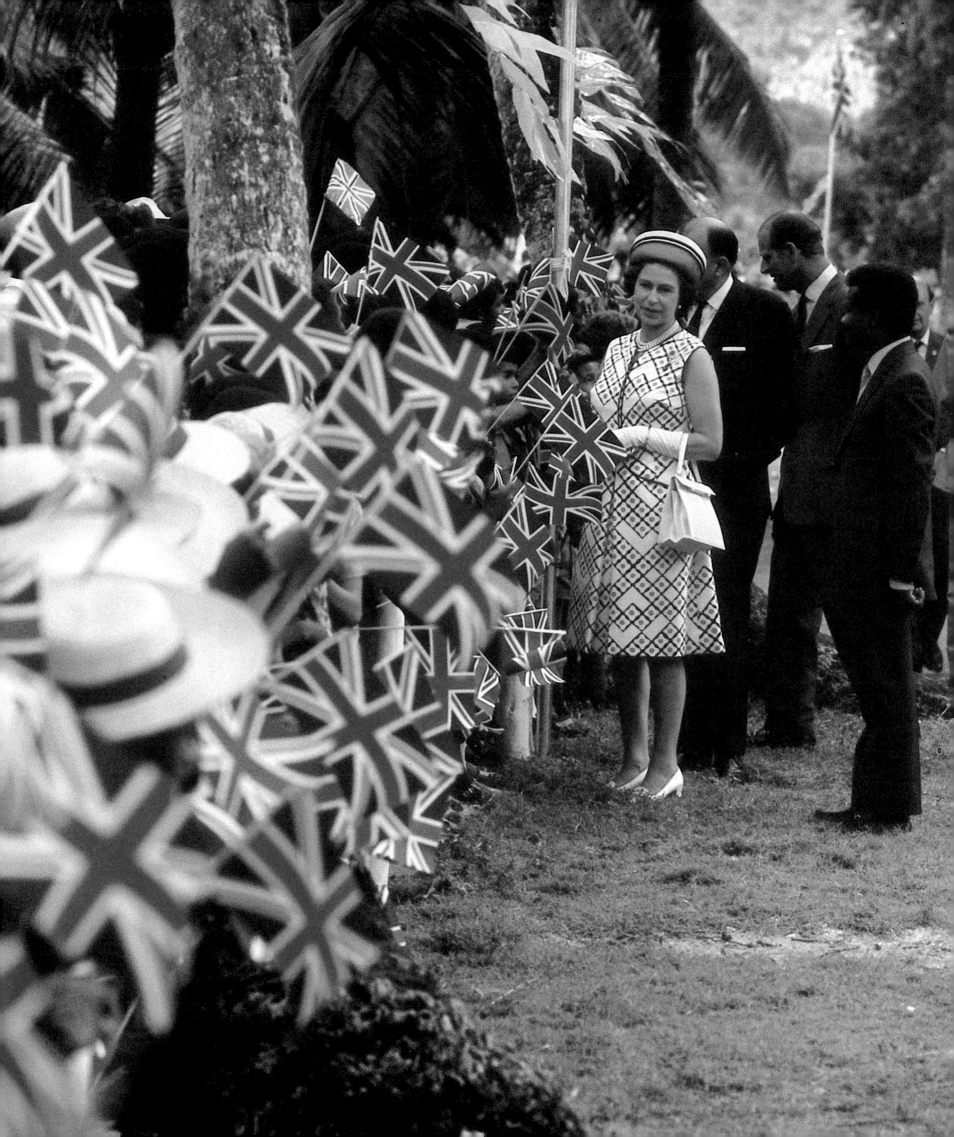

The Queen on a walkabout chatting to the crowds.

Opposite: Schoolchildren of the Seychelles greet the Queen after the opening of Parliament.

*T*he tour ended in Nairobi where these final photographs were taken. The Queen had lunched with President Jomo Kenyatta before watching a magnificently staged display with lots of drums and dancing.
As the Queen boarded the VC10 that was to fly her back to Britain, she paused on the top step to wave goodbye. The President flourished his famous fly-whisk in a final salute.
Because, in many ways, President Kenyatta embodied Kenya it seemed rather incongruous to see him wearing a formal pin-striped suit while surrounded by his colourful tribesmen. But the fly-whisk which he wielded like a sceptre was his hallmark and no one could ever mistake who it was waving at the Queen.

Flanked by President Kenyatta and his wife, the Queen watches a tribal display in Nairobi.

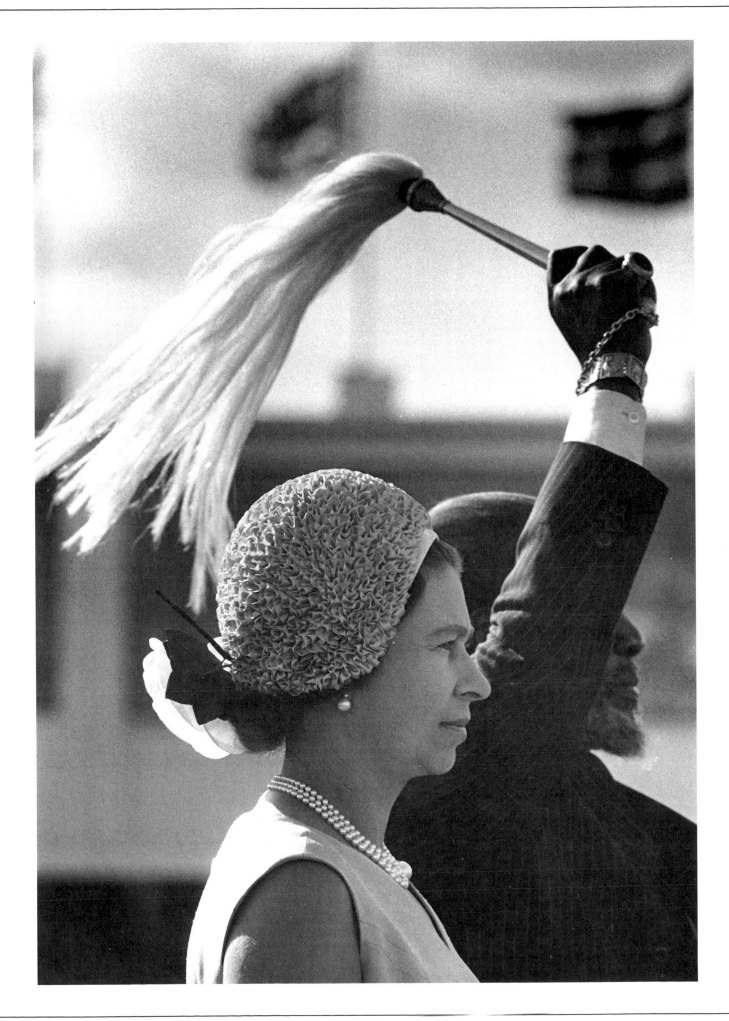

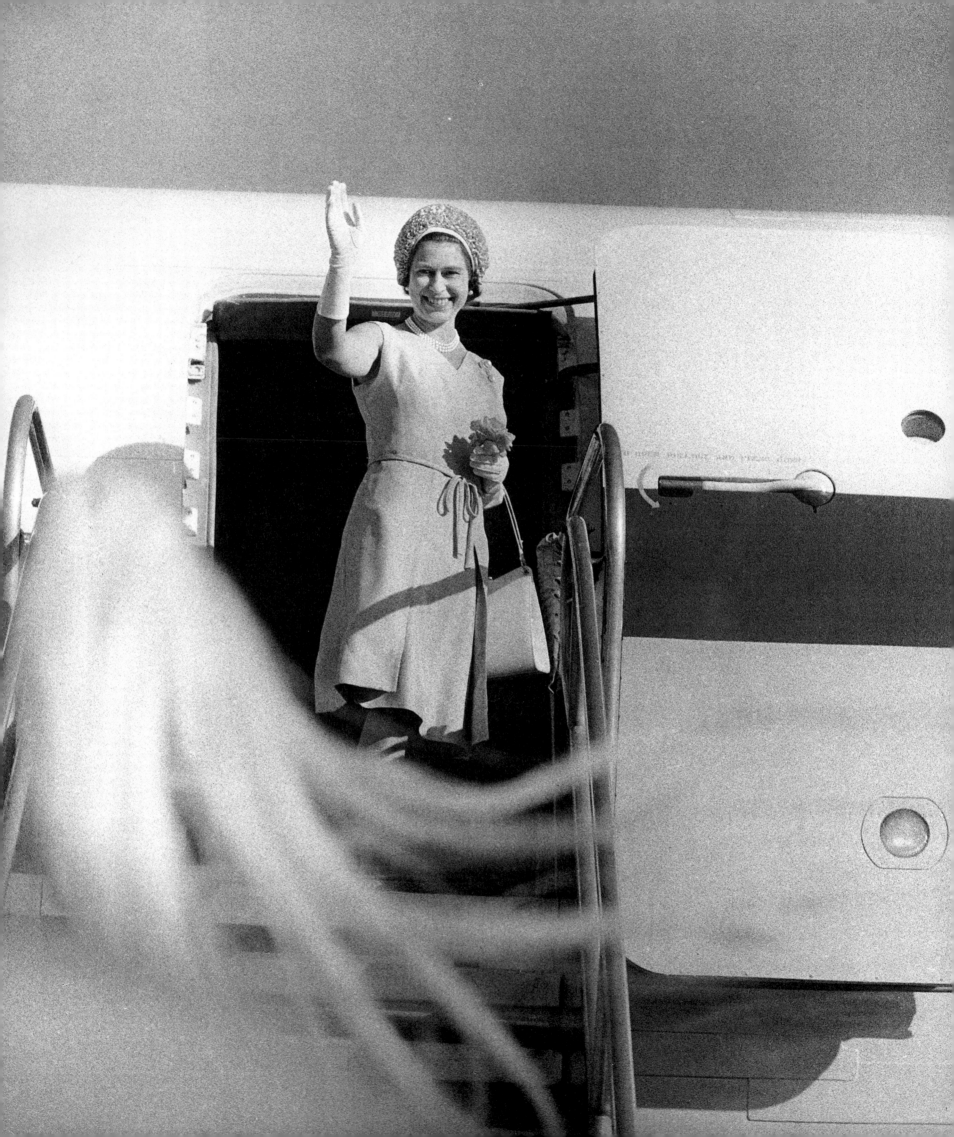

BALMORAL

In the summer of 1971 I was invited to join the royal family at Balmoral Castle during their annual summer holiday. Initially the invitation was to join the shooting but I was asked to bring a camera along to get a special picture for the Queen's Christmas card and also some shots for use during her Silver Wedding anniversary the following year.

Even on holiday the royal family are highly active compared with most people and the scope offered by the Queen's Scottish estate means that there need never be a dull moment, every day is action-packed. One of the family's favourite pursuits is a barbecue which is set up by the lochside. They are all very keen on cooking and such picnics allow them to indulge their expertise to the full, without a footman or a page in sight.

I took this photograph of Prince Philip and Princess Anne with a fairly long lens but I think that despite their concentration on the task in hand they were aware of the camera. They both look very natural, though, absorbed in doing something they enjoy and do well.

These barbecues are very informal affairs: everyone wears casual clothes or kilts. A story is told of a minister, invited to stay at the Castle in order to preach the following Sunday, who, on arriving, was rather startled to be greeted by the Queen wearing oven gloves, a headscarf and apron.

Prince Charles said when he returned from his Mediterranean honeymoon that he thought Balmoral was the most wonderful place in the world and it would be hard to disagree – it does have everything anyone could wish for.

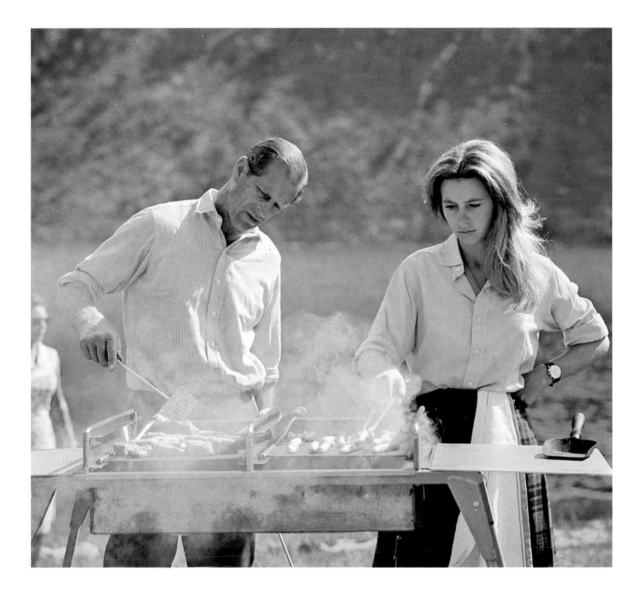

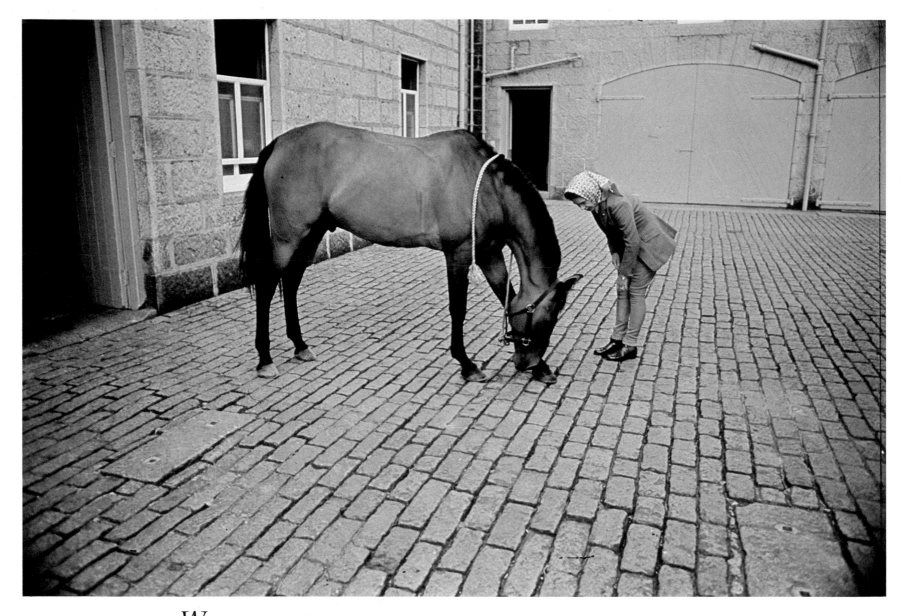

*W*hile I was staying at Balmoral the Queen suggested one day that we go for a ride
to get some good views of the Castle. I must admit that I was not too keen on the
idea: I like riding well enough but not with lots of cameras slung around my neck.
So it was with some misgivings that I set off to the stables with her but it was there,
before the ride had even begun, that I got one of the best shots of the day. The Queen
is very fond of her horses and she walked up to the one she was going to ride to pat it.
I was just about to mount – expensive lenses clashing ominously together – when I
saw the horse put its head down and the Queen lean closer to talk to it. The two
appeared to be bowing to each other and I snatched up the nearest camera and shot the
picture. I only had time to shoot one frame but there it was – one of the most unusual
snaps I have ever taken.

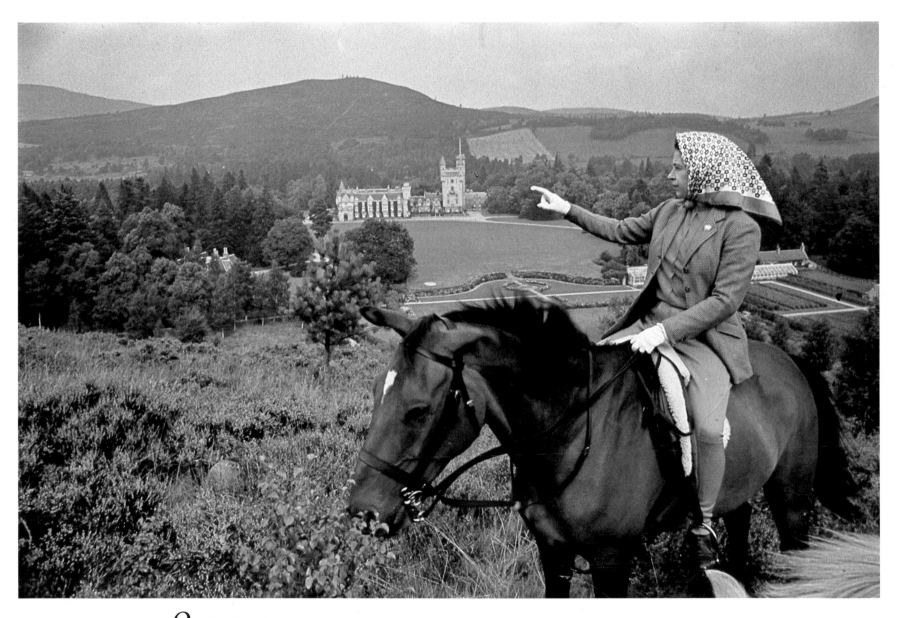

*O*n the day that I went riding with the Queen I also took this shot which has become
one of the most widely used of my photographs of the royal family. Seated on
horseback the Queen seems to be pointing at the Castle but, in fact, she was pointing
out a cairn in the far distance. Still the device worked and I was pleased with the
juxtaposition of the Queen in the foreground with Balmoral behind her that makes it
look almost like a montage.

The grounds of Balmoral are extensive and very beautiful so when a photograph of the Queen was needed for general release we decided to go out into the estate to find a suitable setting.

The Queen knows the grounds very much better than I do and it was she who suggested that she might sit in front of a little waterfall on the burn called Garbh Allt. Her corgis were with her as a matter of course and, as she sat down on a rock, one of them jumped up onto her knee. The pose looked exactly right so I shot it without further ado. I was quite pleased with the result although initially I felt if was perhaps a bit syrupy. In fact it did very well for its intended purpose and sold extensively as a picture postcard.

The Queen is possibly one of the easiest people I know to photograph. She has very regular features and an inexhaustible supply of patience. As a total professional herself she is sympathetic, too, when other people have a job to do.

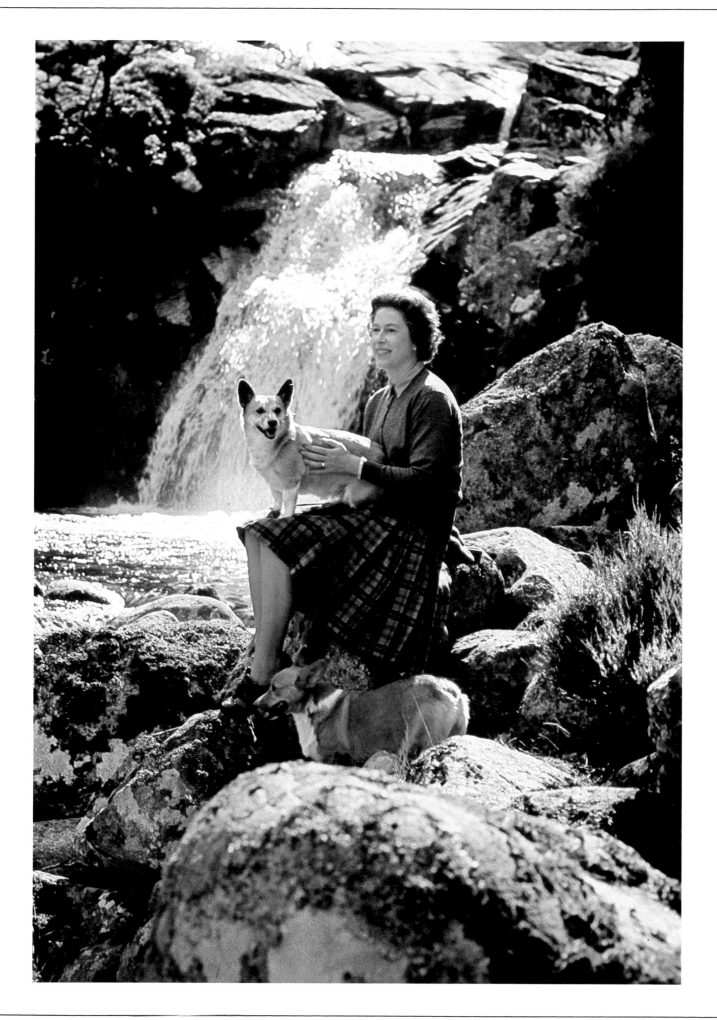

That summer of 1971 I also took this photograph of the Queen dancing at the Ghillies Ball. She gives two such balls every year and they are as much part of the Balmoral holiday as the shooting, the houseparty and the barbecues at Loch Muick.

The Queen is an expert dancer. She seldom misses a reel and lets no one idle on the sidelines. When the band in the gallery strikes up, we are all dragged out on to the floor whether we have the stamina or not. People do tend to practise a bit beforehand because reels can degenerate into chaos if some participants don't know what they are doing. The first reel of the Ball is always an eightsome and the royal family traditionally make up the first set. Like all such affairs, it is a friendly and relaxed occasion, everyone dancing with everyone else. Shown below is the Queen Mother at the ball, obviously enjoying every minute of the festivities. The Queen makes a point of dancing with her head gamekeeper and as many other members of her staff as she can. A Highland regiment is always based at Balmoral during the royal family's stay and, opposite, we see her, the customary tartan sash pinned to her shoulder, gliding elegantly through the intricacies of 'The Dashing White Sergeant'
– with a dashing red sergeant.

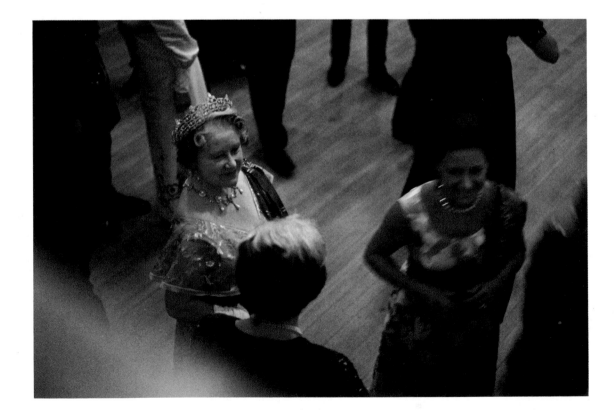

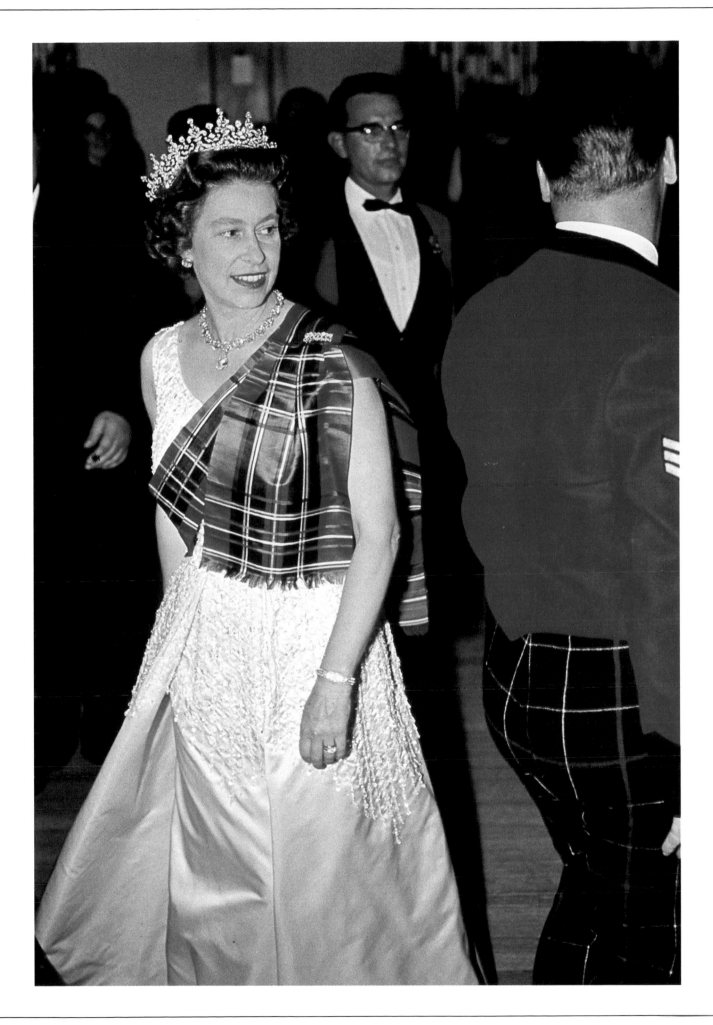

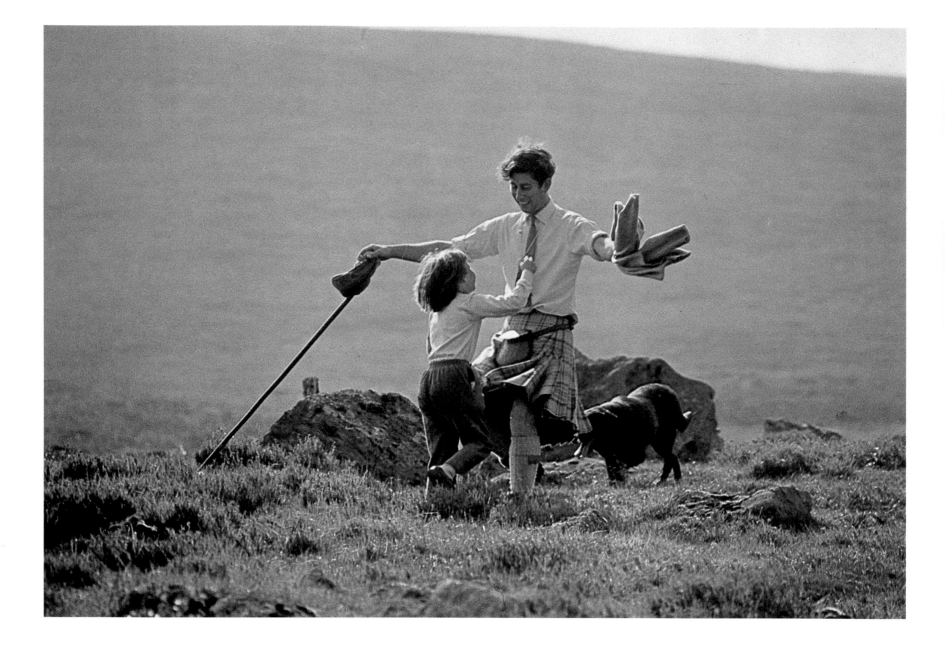

*T*he press called this shot 'Prince Charles's Highland Fling' and other such inaccurate things but in fact it was nothing of the sort. It was a snap taken when we were all out grouse shooting one day.

We had stopped for lunch and Prince Charles was still up the hill picking up his birds when his cousin Lady Sarah Armstrong-Jones arrived to join us. She had been on holiday with her parents in Sardinia and had not seen the Prince for some time. They are very fond of each other and as soon as she saw him on the hill above her, she went dashing up to say hello.

I thought there might be a good picture coming up and, luckily, I had a loaded camera on my knee beside my picnic lunch. As Lady Sarah got nearer to the Prince, I put the camera on motor drive and just fired away. It was an interesting example of reportage photography in that the frame before and the frame immediately after were useless. In one she had not got close enough and in the other they had their arms round each other.

One day, after we had been out shooting and it was just growing dark, I took the Christmas card picture of the royal family. I had been worried that we were leaving it a bit late particularly as it was my only chance to catch them all together. I decided to use the Castle as a background and just fired away. The photograph opposite was taken with them behind the wall but the picture overleaf, the one used as the Christmas card, shows them leaning against it with the Castle behind them. Probably because it was all done so informally the result looks, I think, pleasantly relaxed and casual.

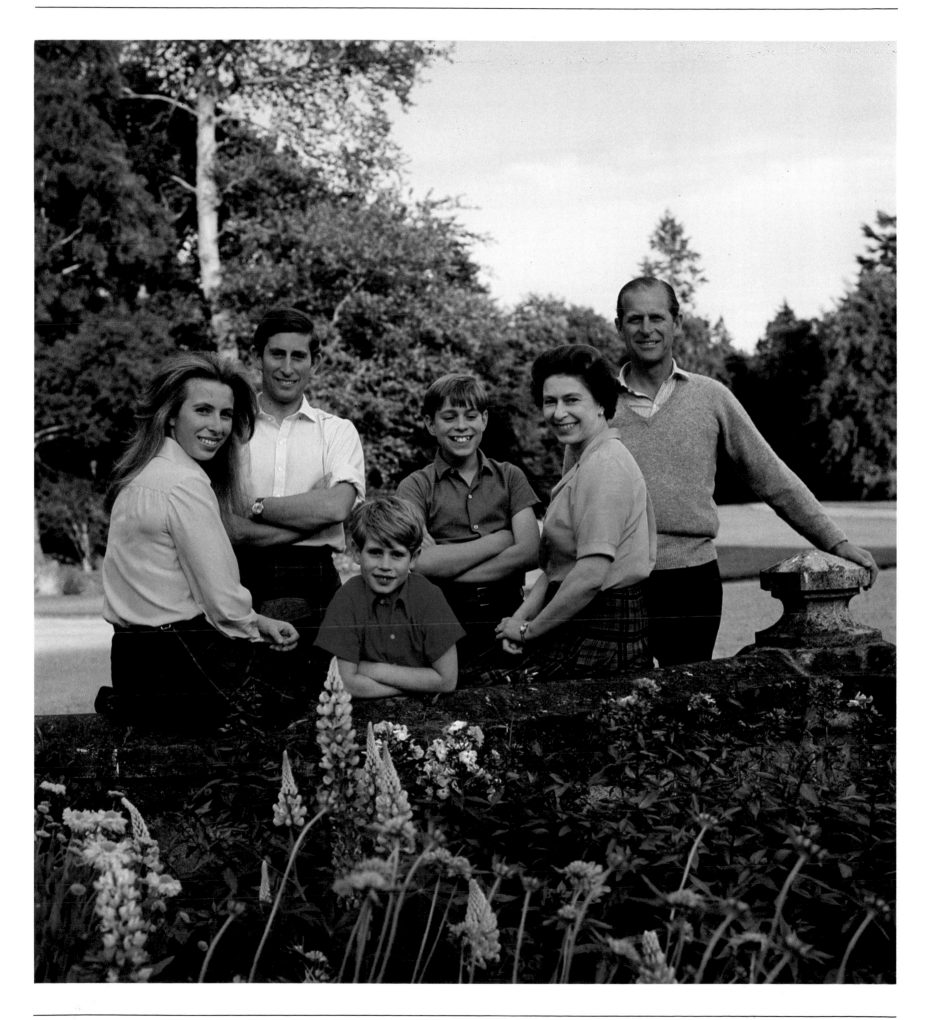

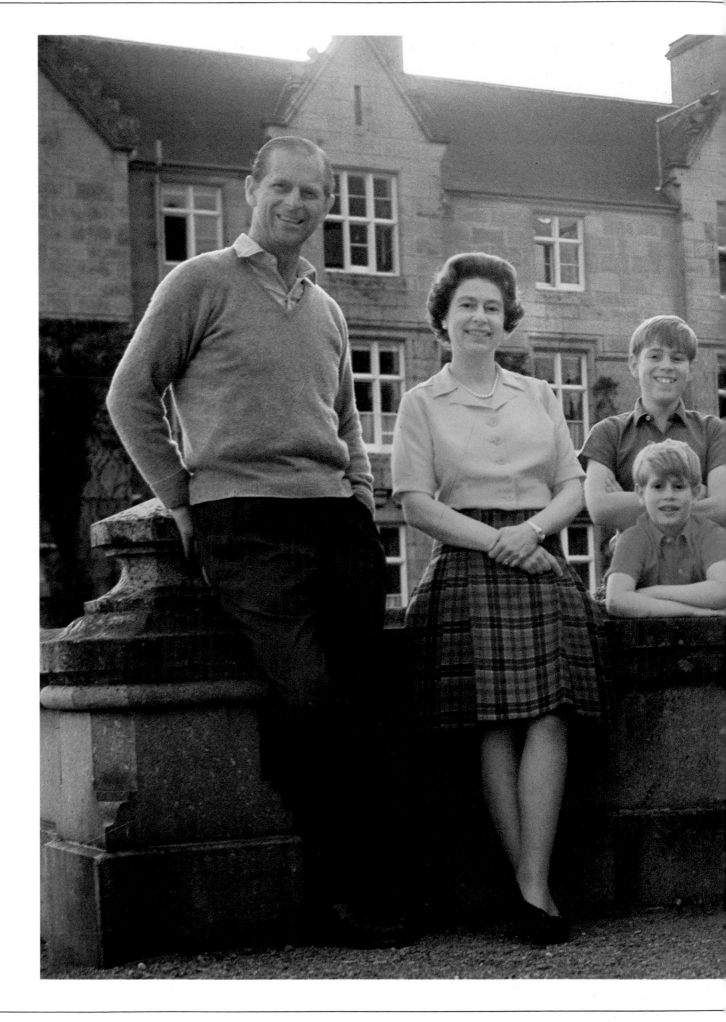

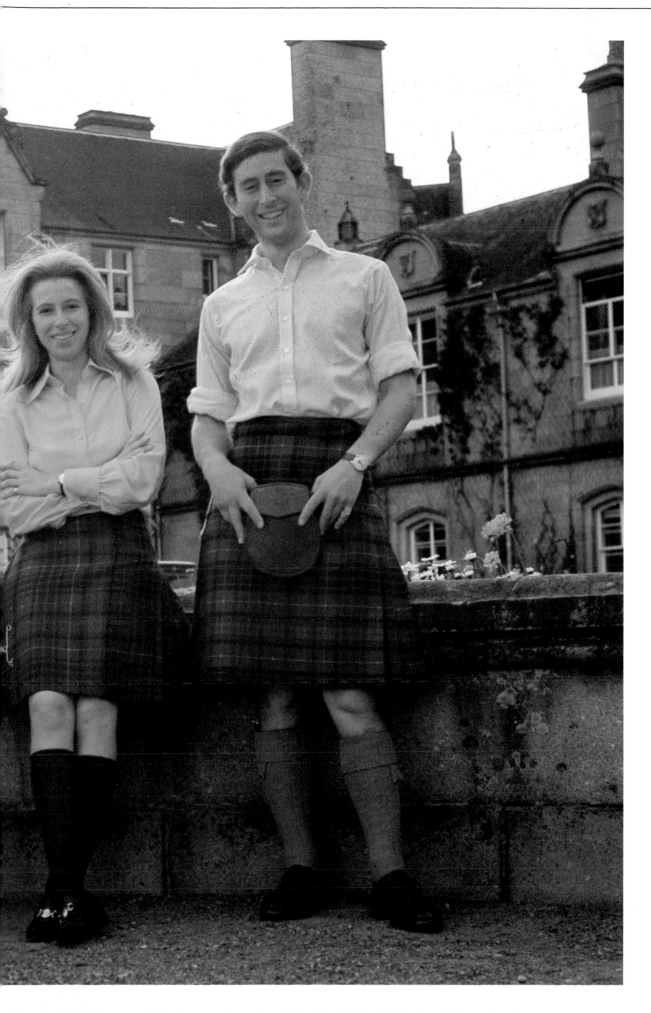

*A*lthough the public tend to associate the royal family with corgis, the Queen is a very skilled handler of sporting dogs and a well respected breeder of labradors. Many a gundog from her Sandringham kennels has gone on to win the top prize at field trials and she gave one of them as a present to President Giscard d'Estaing of France.

This photograph was not pre-planned. I happened to be photographing the Castle when the Queen, with all her dogs, walked out on to the lawn. She kept walking and I kept shooting. I think the dogs give the picture an extra dimension and take away any element of self-consciousness.

I was fortunate that the Queen happened to emerge at that moment. The picture was much easier to shoot than anything I might have carefully arranged and was one of many snaps that I took during that stay at Balmoral.

When I have important people to photograph I find that the adrenalin flows quickly making me more alert and ready to catch the unexpected moment that results in a good photograph.

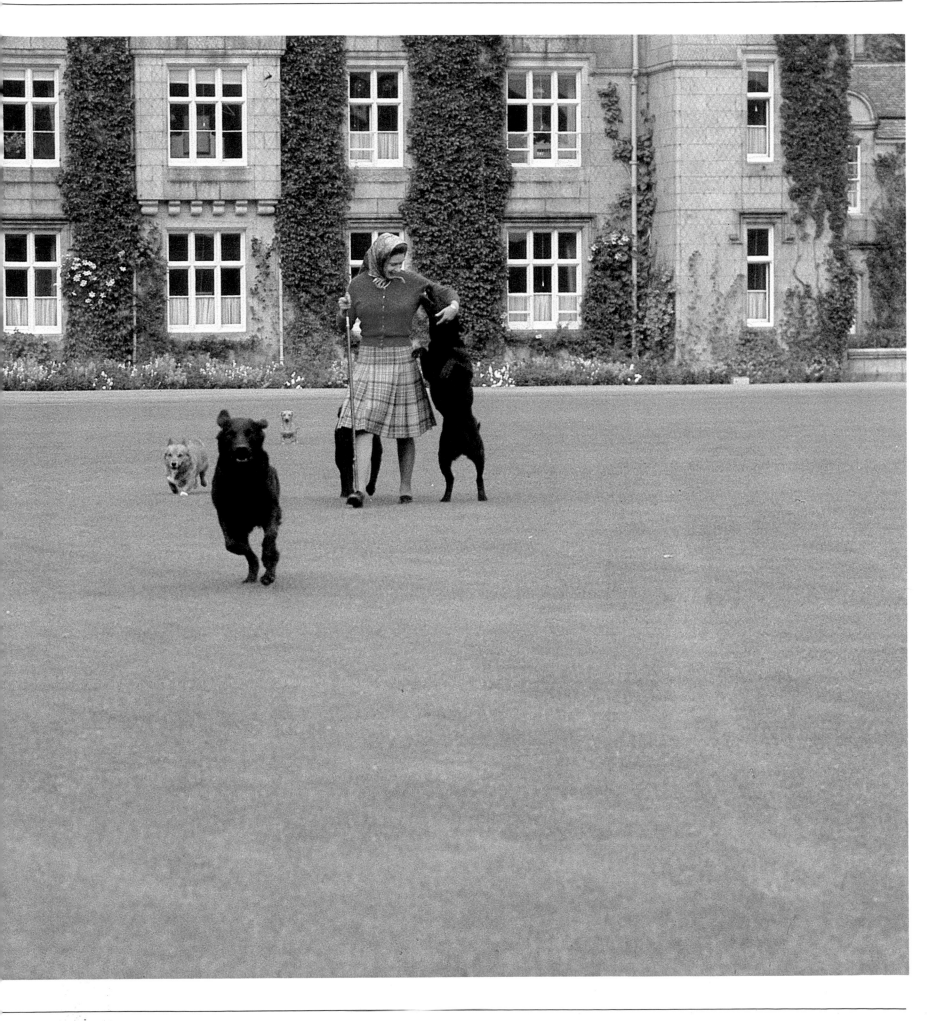

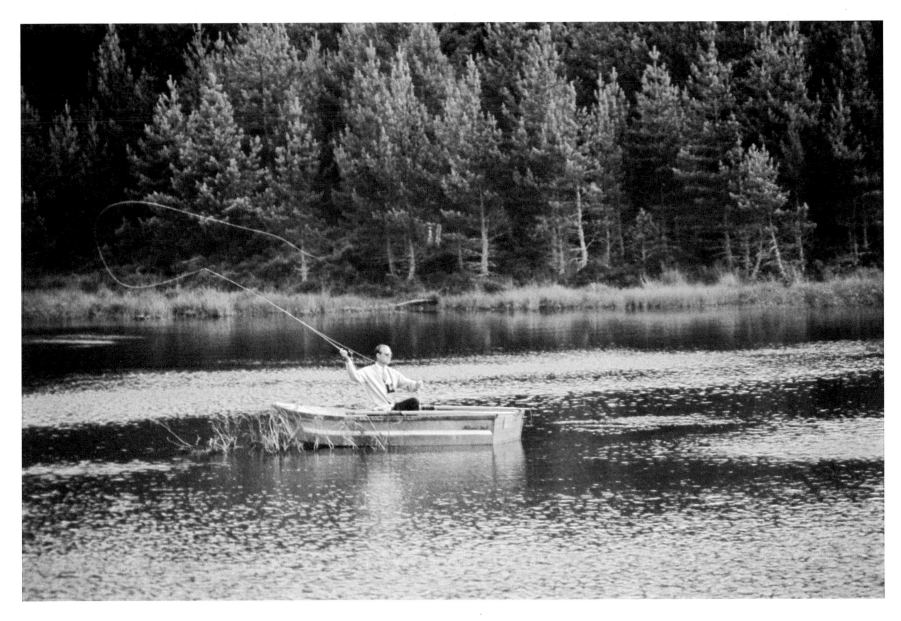

Prince Philip fishing for trout on a small loch.

Opposite: Viscount Linley and the corgis on the edge of Loch Muick.

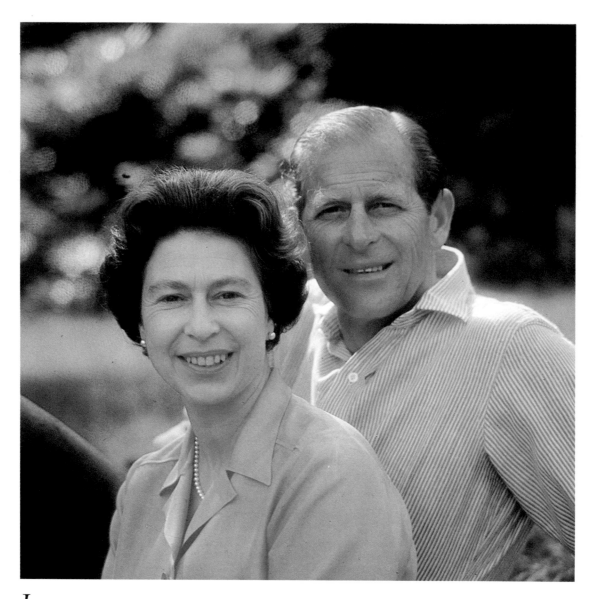

It was just after a barbecue lunch at Balmoral in 1971 that I took this photograph of the Queen and Prince Philip.

The need had suddenly arisen for a double head shot and as I was there on the spot it seemed sensible to get me to do it. So I found myself sitting on the ground trying to do a formal picture for worldwide distribution without an assistant to help or a reflector.

The Queen and Prince Philip, though, showed just what professionals they are. They seated themselves on the grass by the lochside and with no fuss at all did exactly what was expected of them. The picture is backlit which is how I like to photograph people – without the sun in their eyes. It was taken very quickly – I think I only used one roll of film – but every photographer needs his luck and I have had my fair share on fast shoots like that one.

When I was in Australia in 1977 for an exhibition of my work, I saw that the photograph was used on their Silver Jubilee stamp. I bought a sheet of the stamps to mount under the original picture in the exhibition and it was only then that it dawned on me that the exhibitors had printed the photograph back to front.

THE
ROYAL FAMILIES
OF EUROPE

Norway

When I travelled to Oslo to photograph King Olav V, I had forgotten something rather crucial. It was not until the King himself reminded me that I realised they only have two hours of daylight in Norway in the winter. It was a pity as I had wanted to use natural light for the session, but, eventually, I was forced to resort to artificial light and finished the photographs in one day.

King Olav was very cooperative. He is easy to work with – jolly and robust and full of bonhomie. He is an old friend of Britain (his Danish father, King Haakon, was married to Princess Maud, youngest daughter of King Edward VII and Queen Alexandra) and comes here every year for the Ceremony of Remembrance at the Cenotaph. I have known him most of my adult life. His wife, Princess Martha, died sadly in 1954 and he lives with his son Crown Prince Harald, born 1937, and his daughter-in-law Sonja Haraldsen. He also has two daughters, Princess Ragnhild, born 1930 and Princess Astrid, born 1932. Crown Prince Harald and his wife have two children: Princess Märtha Louise, born 1971 and Prince Haakon, born 1973, who is heir to the throne.

Opposite: Crown Prince Harald and his wife Crown Princess Sonja.

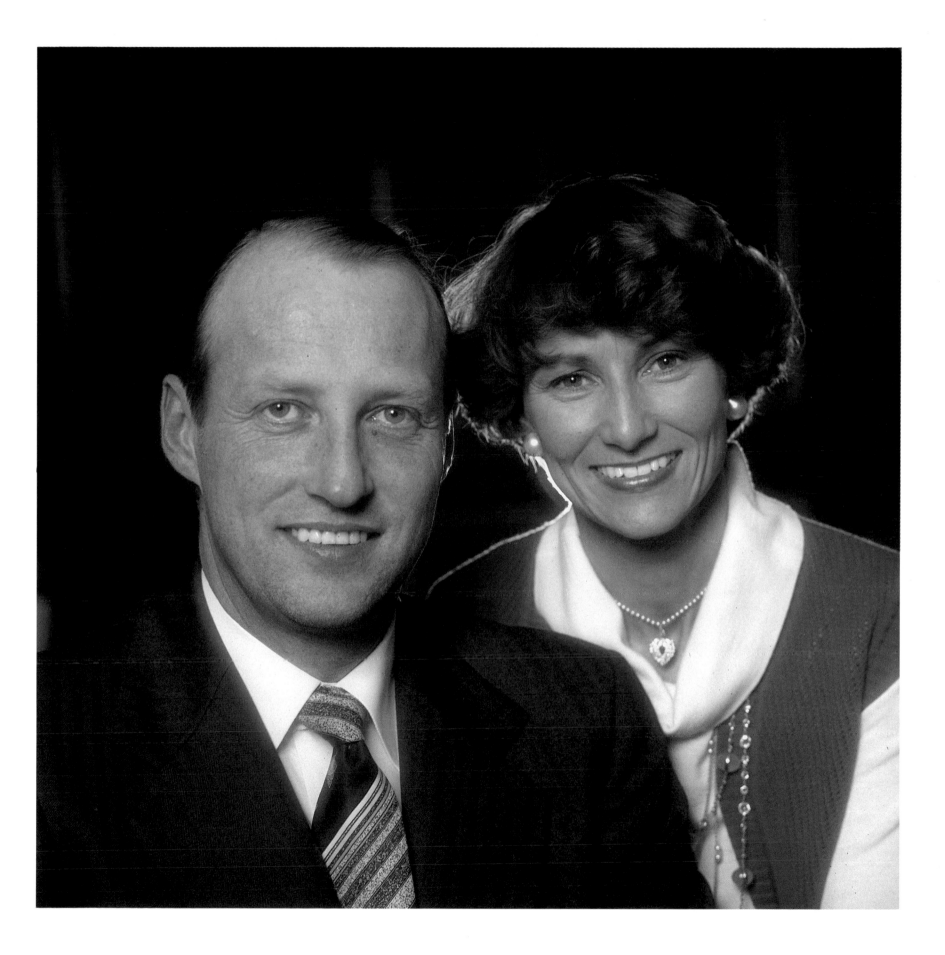

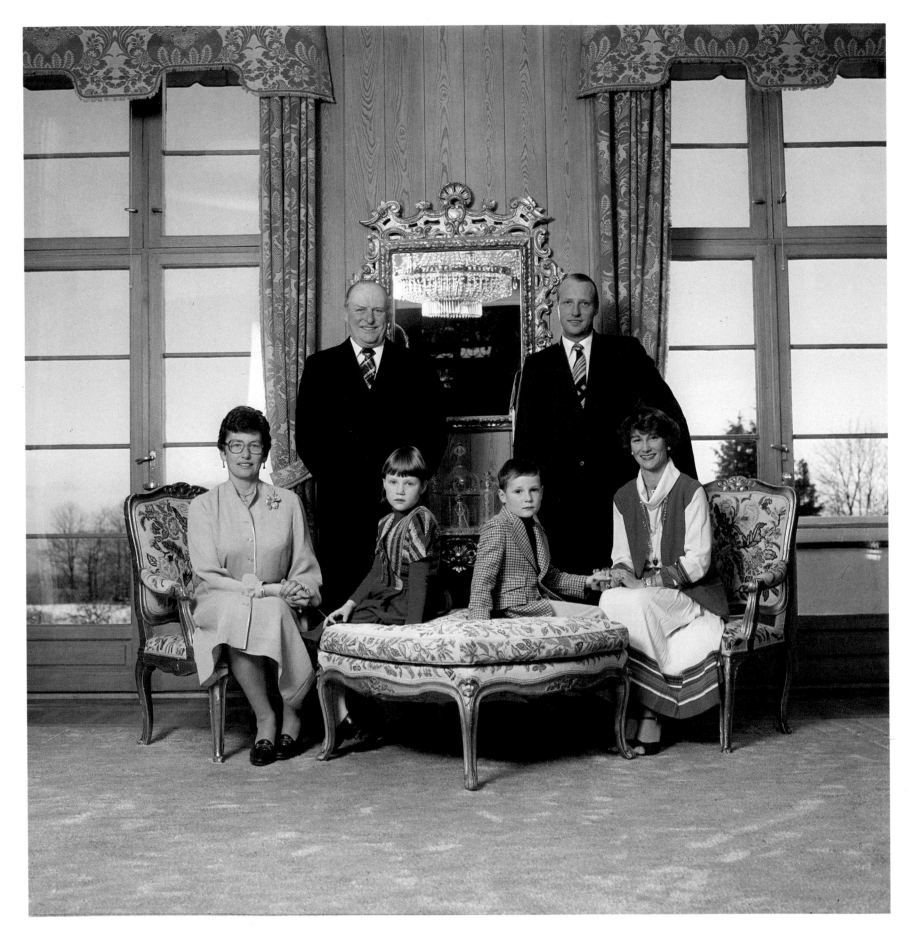

King Olav, back left, and Crown Prince Harald with, seated, Princess Astrid, Princess Märtha Louise, Prince Haakon Magnus and Crown Princess Sonja.

Denmark

*W*hen I was commissioned nearly twenty years ago in 1964 to photograph Princess Anne-Marie of Denmark for the Daily Express, I was predictably nervous. I had never photographed, officially, any member of any royal family before and what made it even more difficult was that I knew the Danish royal family personally. My step-father is Prince Georg of Denmark and I had met the younger members of the family as a child going to the theatre with them and on other outings. Now I had done a very strange thing and turned into a tradesman.

Impecunious and unknown photographer that I was, my nervousness was compounded when, on turning up at the Fredensborg Palace far too early, I was told that the Queen was still out and her daughters – including the eighteen-year-old Princess who was due to marry King Constantine of Greece only a few days later – were understandably rather busy.

After a restless wait in a small ante-room, I was finally ushered into the drawing room where the whole family was assembled having tea. No scene more essentially English could possibly be imagined but then Queen Ingrid was part English being descended from Queen Victoria.

As I approached the table, the Queen shook hands and poured out a cup of tea for me – filled to the brim. She picked it up and handed it to me but, all too aware that my hands were shaking, I knew that I couldn't take the cup from her. She tactfully noticed my dilemma and putting the cup on a little table, urged me to sit down and relax. King Frederik suggested that I might like to take off my jacket as it was such a hot day. It was only when my jacket was half way off, that an awful thought struck me. I was wearing a shirt with no right sleeve. Impoverished as I was, I used to chop off the sleeve when my shirts wore through at the elbow and anchor the cuff strategically to the jacket.

More embarrassment, but it gave rise to something worth remembering. On my right arm I have a tattoo. Sleeveless arm all revealed, the King looked at the tattoo and said, 'That was done by Mr Birchett in the Waterloo Road, wasn't it?'

Not the kind of question you expect really from the King of Denmark and I was even more astonished when he proceeded to strip to the waist and reveal a torso completely covered in tattoos. It transpired that during his years in the Navy he had passed by Singapore, Malaya, Hong Kong and Mr Birchett in the Waterloo Road and had collected a tattoo at most ports of call. He knew precisely who had done each one and was astoundingly accurate. He was rather like a Christie's art expert on tattoos.

(The reason why I have a tattoo on my right arm is quite simple. I admire Lord Snowdon's work very much and I had read his book London which included a photograph of Mr Birchett. The day I left the army, I, keen amateur photographer, decided to go down to the Waterloo Road to see if I could get a shot of Mr Birchett myself. I never did get a really good photograph of the man but I did let myself be persuaded into having a 7s 6d tattoo, which took twenty minutes to do and was agony for every one.)

Not unnaturally, after these events the ice was completely broken and, feeling a lot better, I not only took photographs of Princess Anne-Marie but of the whole family as well.

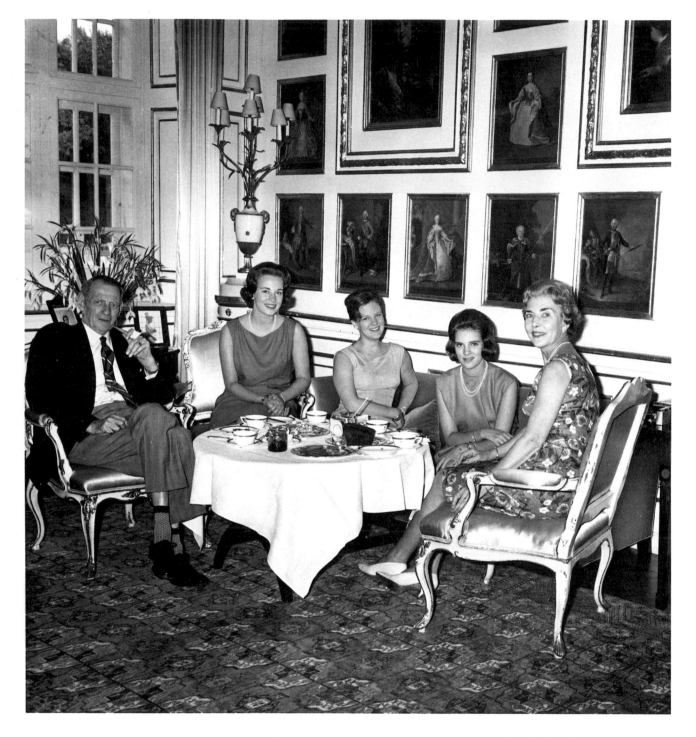

The photograph above shows them having tea. Left to right: King Frederik, Princess Benedikte, Princess Margarethe, Princess Anne-Marie and Queen Ingrid.

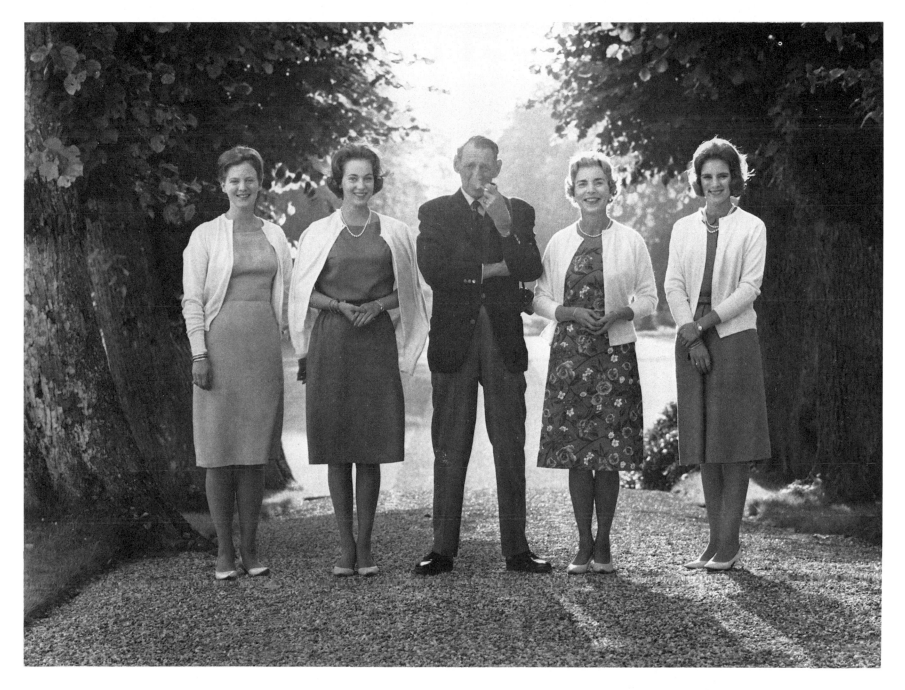

The three princesses: Princess Margarethe, now Queen of Denmark; Princess Benedikte (b. 1944) now married to Prince Richard zu Wittgenstein-Berleburg and Princess Anne-Marie (b. 1946), now, ex-Queen of Greece, with their mother and father in the garden.

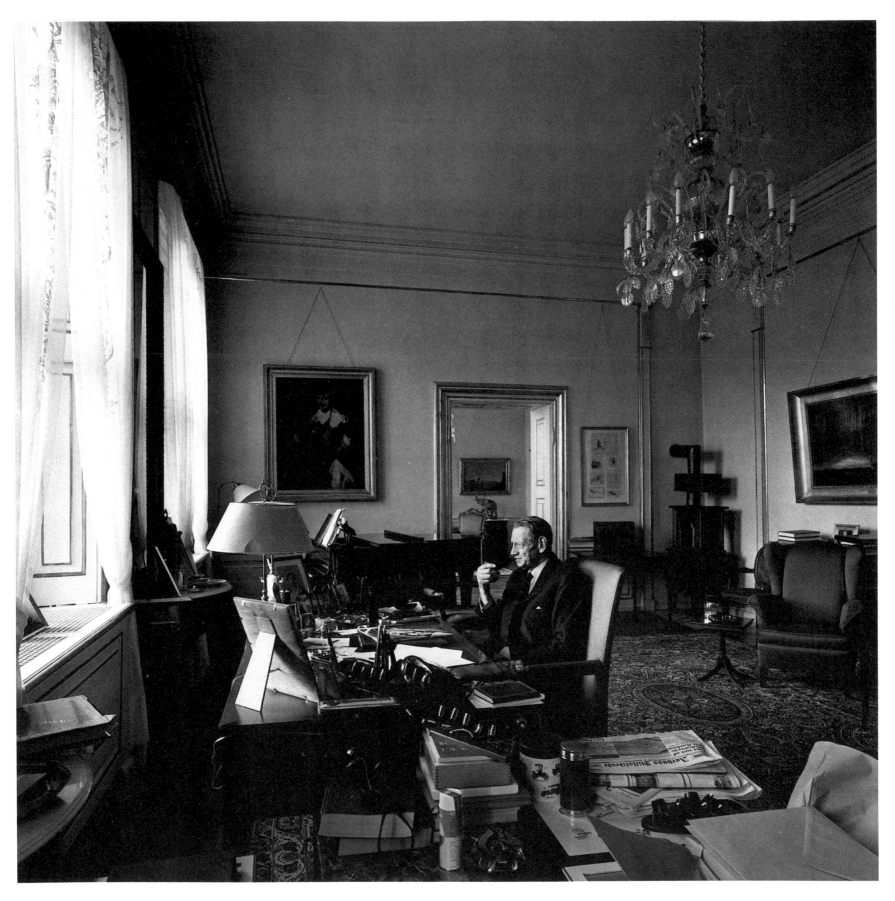

King Frederick IX of Denmark in his study

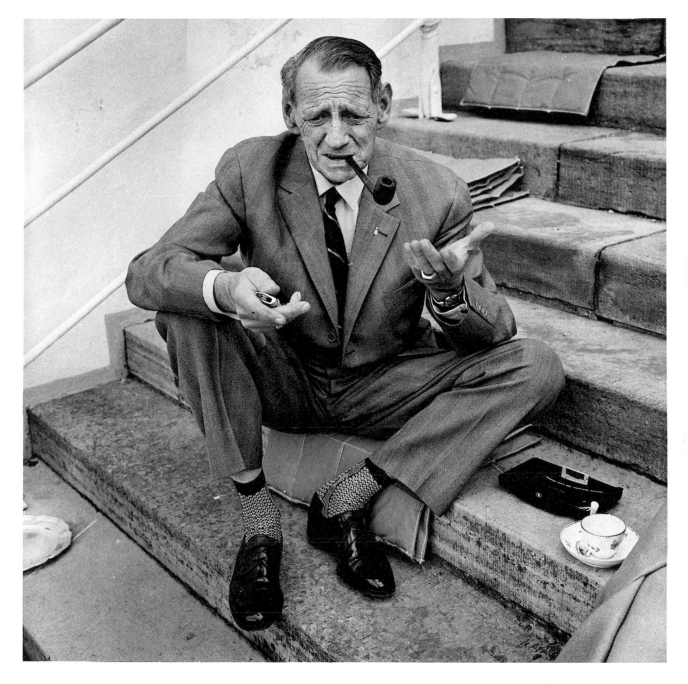

The King relaxing on the steps leading up to a terrace at the rear of the Palace.

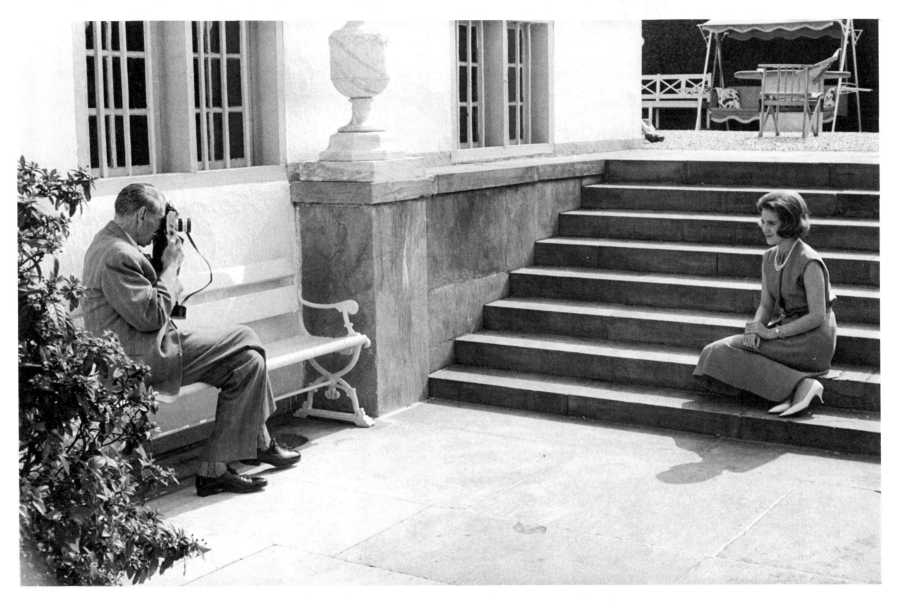

The King photographing his daughter, Princess Anne-Marie, on the same set of steps and opposite, a similar pose taken by me.

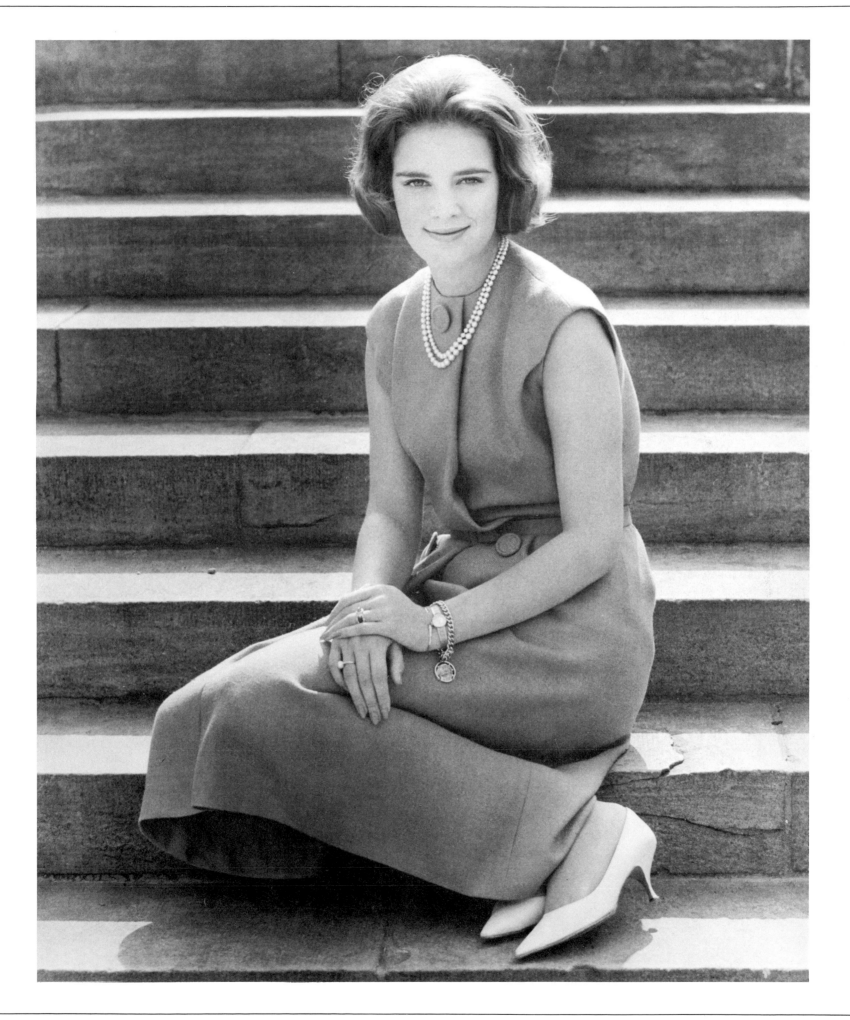

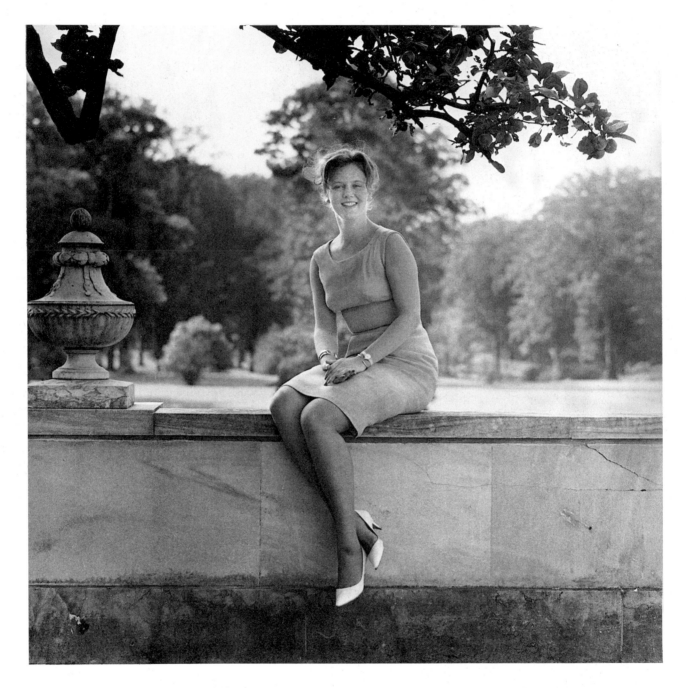

Princess Margarethe atop the terrace wall with the gardens as a backdrop.

Some years later I took this photograph of the present Queen of Denmark, Margarethe, with her two sons, Prince Frederik and Prince Joachim, and her consort, Prince Henrik, standing in the grand saloon at Fredensborg.

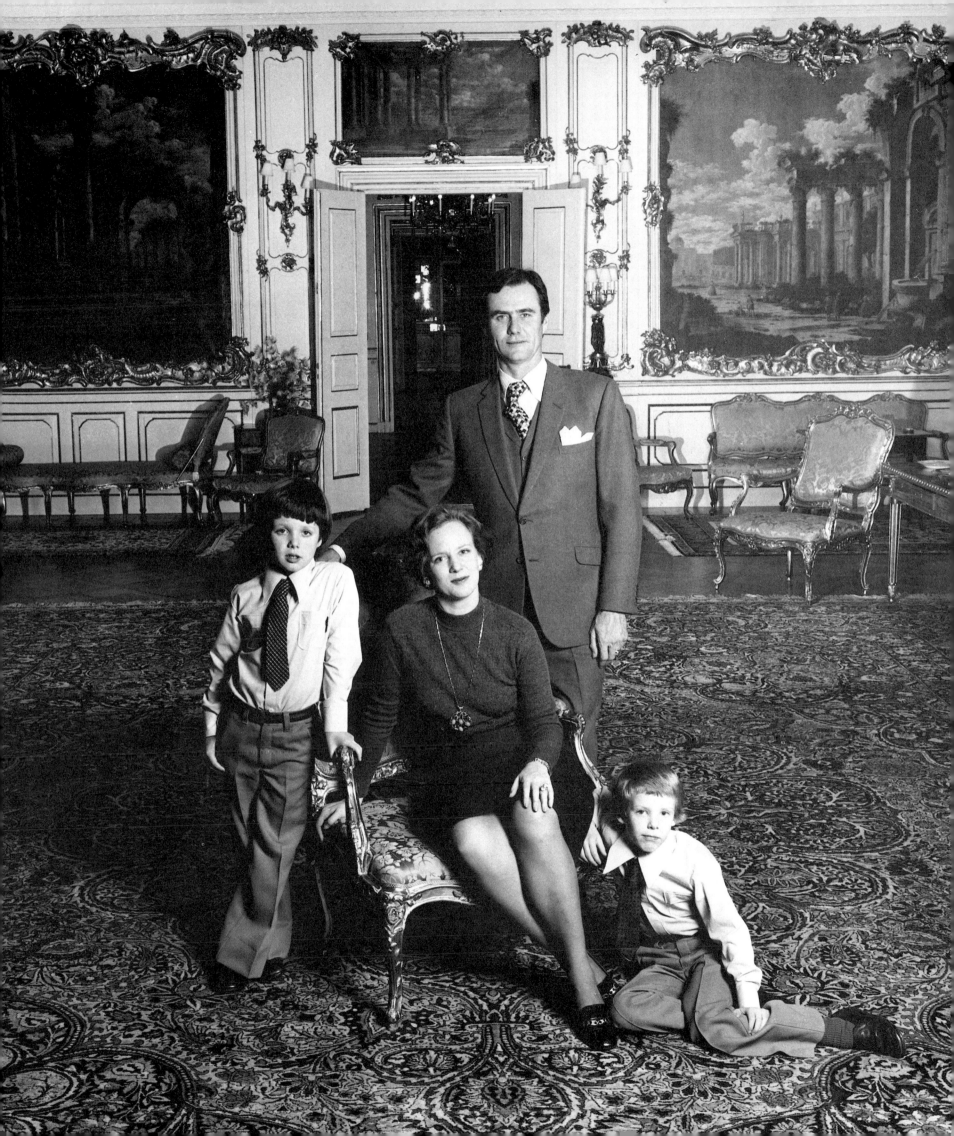

Greece

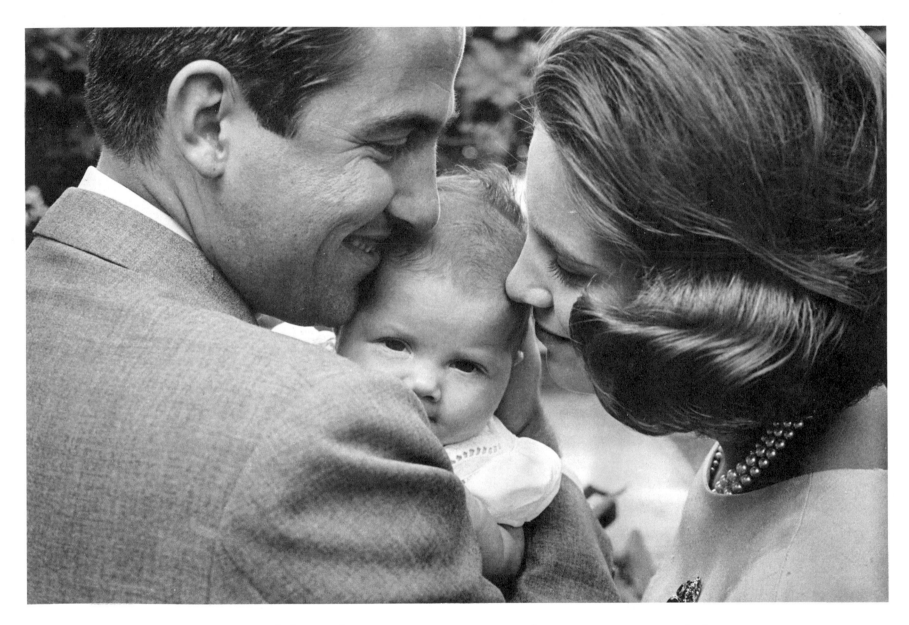

The King and Queen of Greece, King Constantine and Queen Anne-Marie with their first born child, Princess Alexia. Opposite is a photograph taken in London some years later, in 1971.

King Constantine and Queen Anne-Marie now have three children: Princess Alexia, born in 1965, Prince Paul, born in 1967 and Prince Nicholas born in 1969 after they had been exiled from Greece.

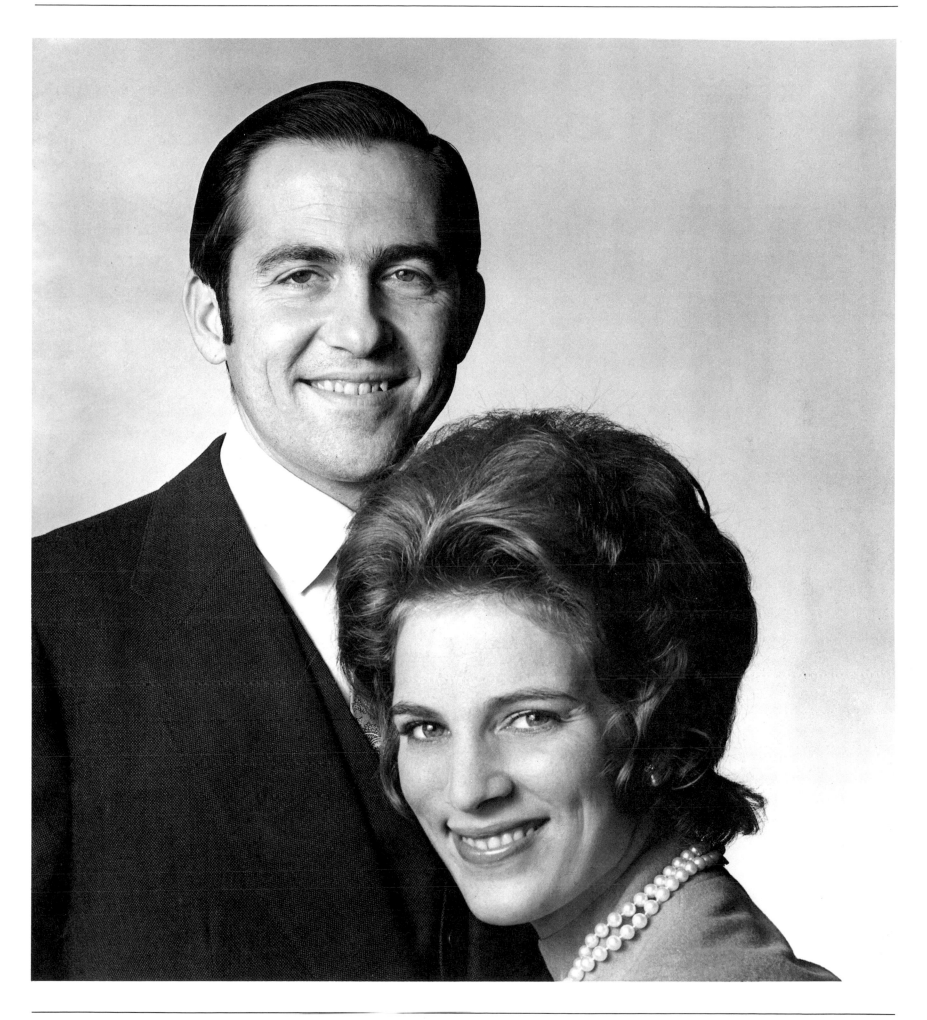

Liechtenstein

I nearly got lost trying to find Liechtenstein – it is such a small place – but when I finally arrived it was well worth the effort. The royal family live in a spectacular castle perched on an outcrop of rock high above the main town, Vaduz. The castle is built round an ancient walled courtyard and is full of the most impressive paintings.

The Queen and Prince Philip are close friends of Prince Franz Joseph and Princess Gina and stayed with them in Liechtenstein after a state visit to Switzerland two years ago. They thoroughly enjoyed strolling through the narrow streets buying souvenirs just like any other visitors.

All the photographs are carefully posed – that was the nature of the commission – but I tried to make them look as natural and informal as possible. Prince Franz Joseph and Princess Gina have five children: Prince Hans-Adam who is the heir, born 1945, Prince Philipp Erasmus, born 1946, Prince Nikolaus, born 1947, Princess Nora, born 1950 and Prince Wenzel, born 1962.

Prince Franz Joseph

Princess Gina poses in one of the magnificent doorways of the castle in Vaduz.

The Aga Khan

I *have never known anyone who keeps such a tight schedule as the Aga Khan – the*
amount that he packs into any one day is awe-inspiring. So when I was commissioned
by the then editor and proprietor of Queen *magazine, Mr Jocelyn Stevens, to go to*
Sardinia to photograph him, my idea that we take a four-hour mountain trek did not
immediately appeal to him.

The Aga Khan had just completed a very impressive development in the Costa
Smerelda which I had already photographed. I thought it would be an attractive idea to
photograph him on a mountain top with the development behind him. It took some
persuasion but, as he had liked my previous pictures, he kindly agreed to my
suggestion. So we trudged up the mountain track to the top and he posed precariously
on the highest point.

I took a large number of colour shots and just a few black and white but the person
who had come along to help me with the equipment managed to drop almost all the
film somewhere on the way down the mountain so I ended up with practically nothing
to show for all our effort.

I like the degree of informality about this shot shown overleaf – particularly the fact
that the Aga Khan is wearing gym shoes. Not something I would have planned in
advance but a nice touch which just goes to show that sometimes it's better not be too
well organised.

Holland

I first photographed members of the Dutch royal family at the wedding of Princess Beatrix to Prince Claus von Ausburg. My sister was a bridesmaid and I was there to do a private series of photographs.

I remember on the eve of the wedding, the bride's friends, true to Dutch custom, put on a play about the Princess's life in the Palace theatre. Although I couldn't understand a word of it, it was very funny and much enjoyed by the audience.

Over the years the Queen and the Prince have become close personal friends and I have photographed them many times subsequently, particularly with their firstborn child, Prince Alexander. He was the first male heir to the throne for three generations and everyone was understandably delighted.

They are a very informal family. Queen Beatrix and Prince Claus live a relatively simple and unpretentious life with their three sons in a small but perfect house called Drakensteyn. The Queen Mother, Queen Juliana, is like a very cosy grandmother and so sweet that it's sometimes difficult to remember how royal she is. The family could not be easier to photograph – like all royalty they have the two great virtues: patience and practice.

An informal moment at Princess Beatrix's wedding to Prince Claus.

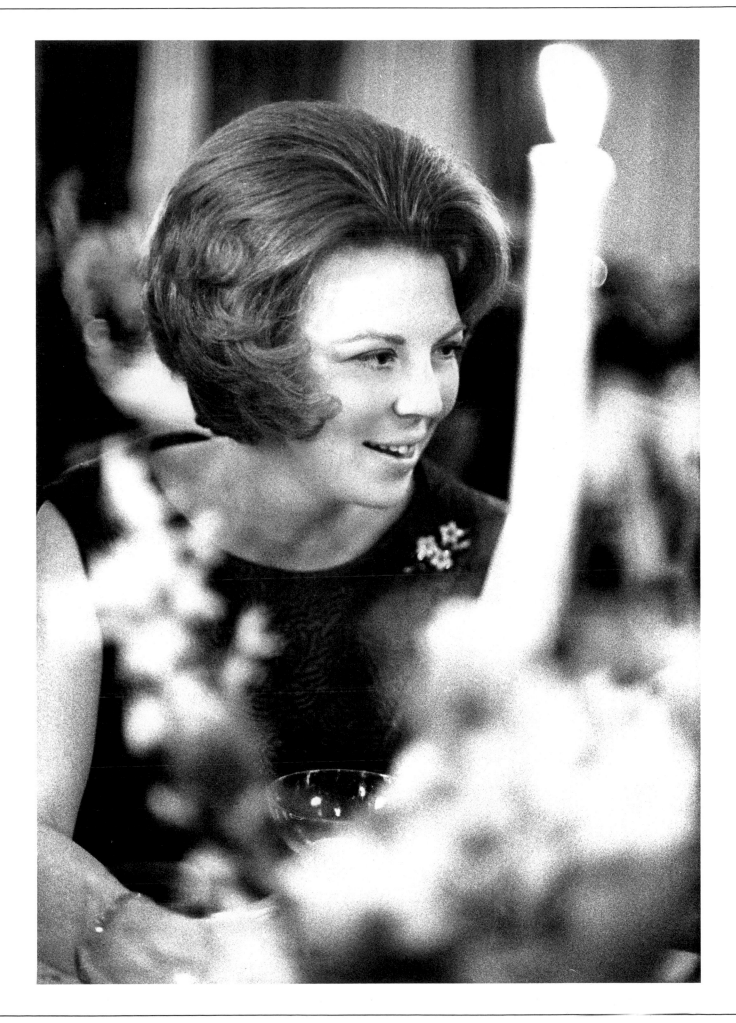

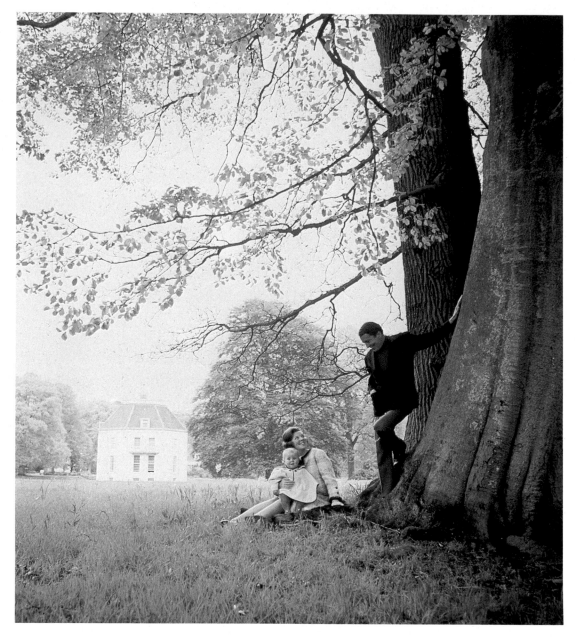

*Queen Beatrix, Prince Claus and their son, Prince Alexander, in the park surrounding
their beautiful home.*

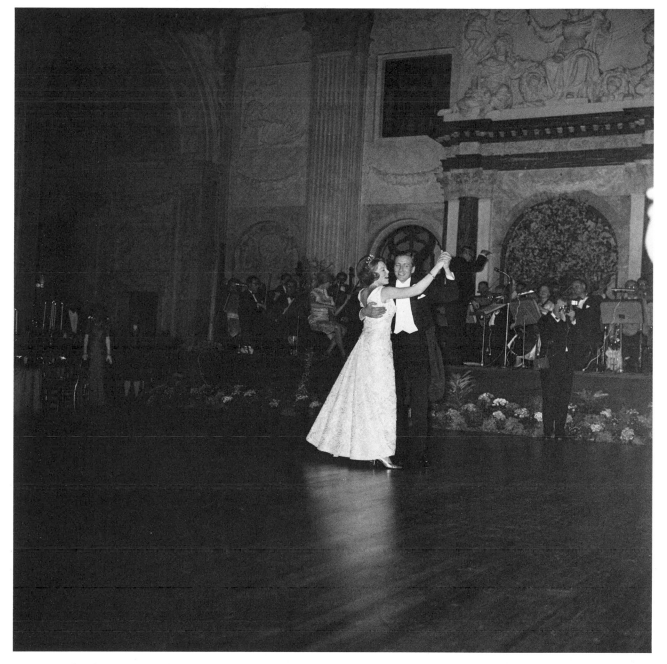

The first waltz. Princess Beatrix and Prince Claus take to the floor on the eve of their wedding.

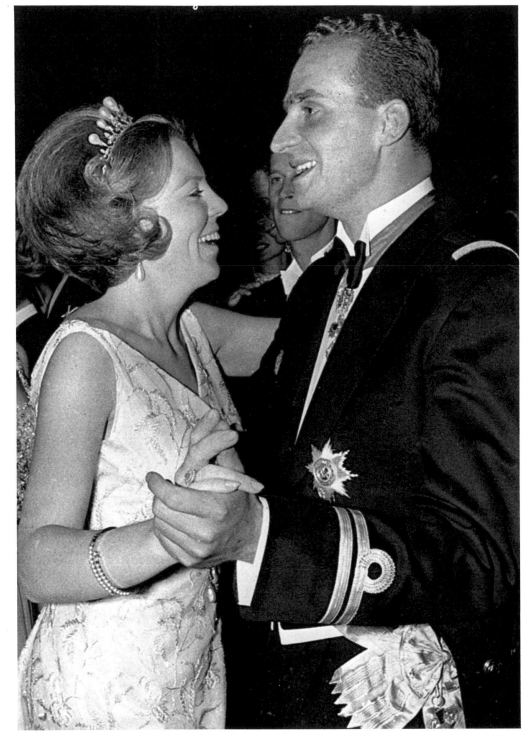

That same evening, Princess Beatrix dancing with Prince Juan Carlos of Spain.

Roumania

The only Christmas I ever spent away from home as a child was at Bramshill, a very large country house in Hampshire owned by Lord Brockett. It had been taken by the ex-King and Queen of Roumania, King Michael and Queen Anne, who were friends of my mother and my step-father Prince Georg of Denmark, and had invited us for the holiday.

I was only about twelve at the time and rather doubtful about spending Christmas away from home – a prospect rendered even more daunting if you were not used to kings, even ex-kings. In the event they could not have been kinder and the holiday was magical. It became one of those golden memories of childhood and so, when I was commissioned to photograph them many years later, I was delighted.

The King and Queen have five daughters: the Princesses Margarita, born 1949, Elena, born 1950, Irina, born 1953, Sophie, born 1957 and Marie, born 1964.

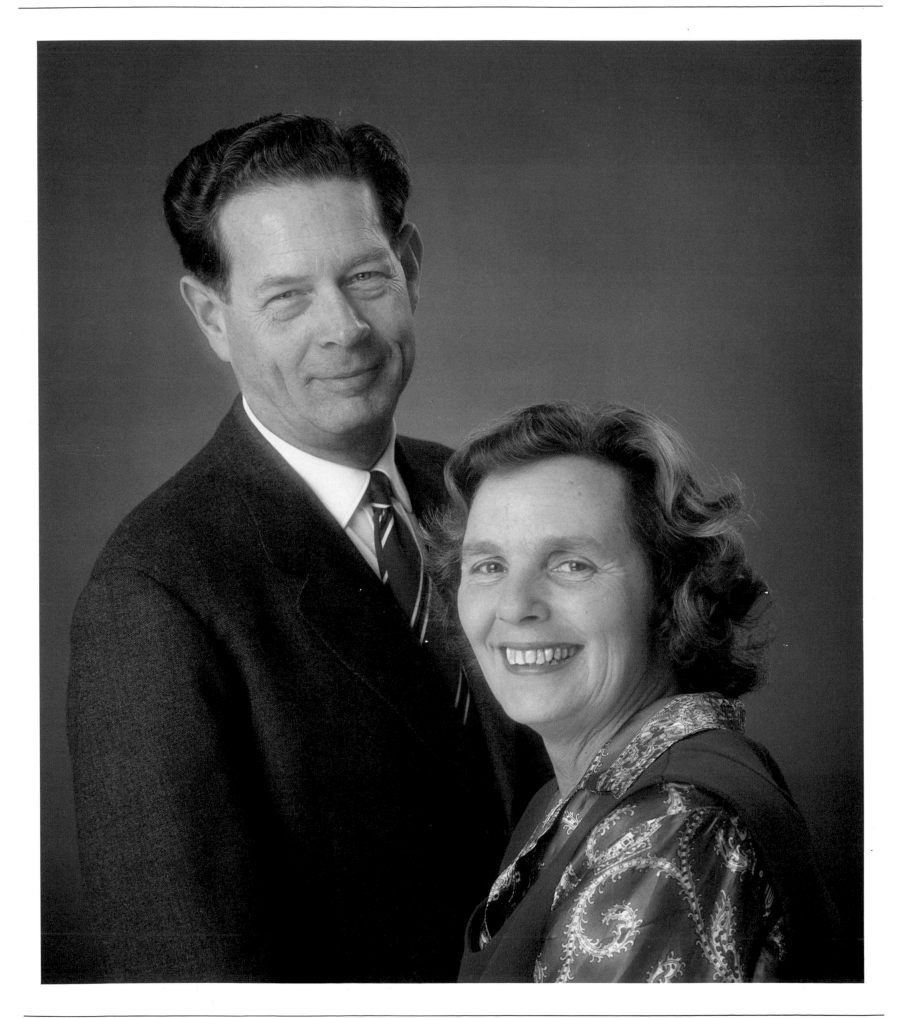

Opposite. King Michael and Princess Anne of Bourbon-Parma married in 1948, when he had already become a king without a kingdom.

Their two daughters – left: Princess Elena. Right: Princess Irina

Luxembourg

I *was commissioned to photograph the Grand Duke and Duchess of Luxembourg
following a chance meeting with Grand Duke Jean at a party at the Fredensborg Palace
in Denmark.*

*I spent just the one day with family and, learning from a disastrous session I once had
with the Duke and Duchess of Kent and their children (see page 87) I took care not to
make the poses stiff and formal, and photographed them in their natural surroundings,
wearing their everyday clothes and looking as relaxed and unposed as possible. The
Grand Duke and Duchess's children were still quite young and I have found that trying
to put younger children into formal poses can be very difficult. They have five children:
Prince Henri, born 1955, Princess Marie-Astrid, born 1954, twins Prince Jean and
Princess Marguerite, born 1957 and Prince Guillaume, born 1963.*

*It can be very easy to lose children's attention when doing formal groups as any
wedding picture will testify. Sometimes, especially if we've never met before, I take the
children off on their own and let them get to know me. If they like you and are feeling
cooperative it can make all the difference.*

*The photograph opposite shows the Grand Duke and Duchess Joséphine-Charlotte in
their garden in discussion with their gardeners.*

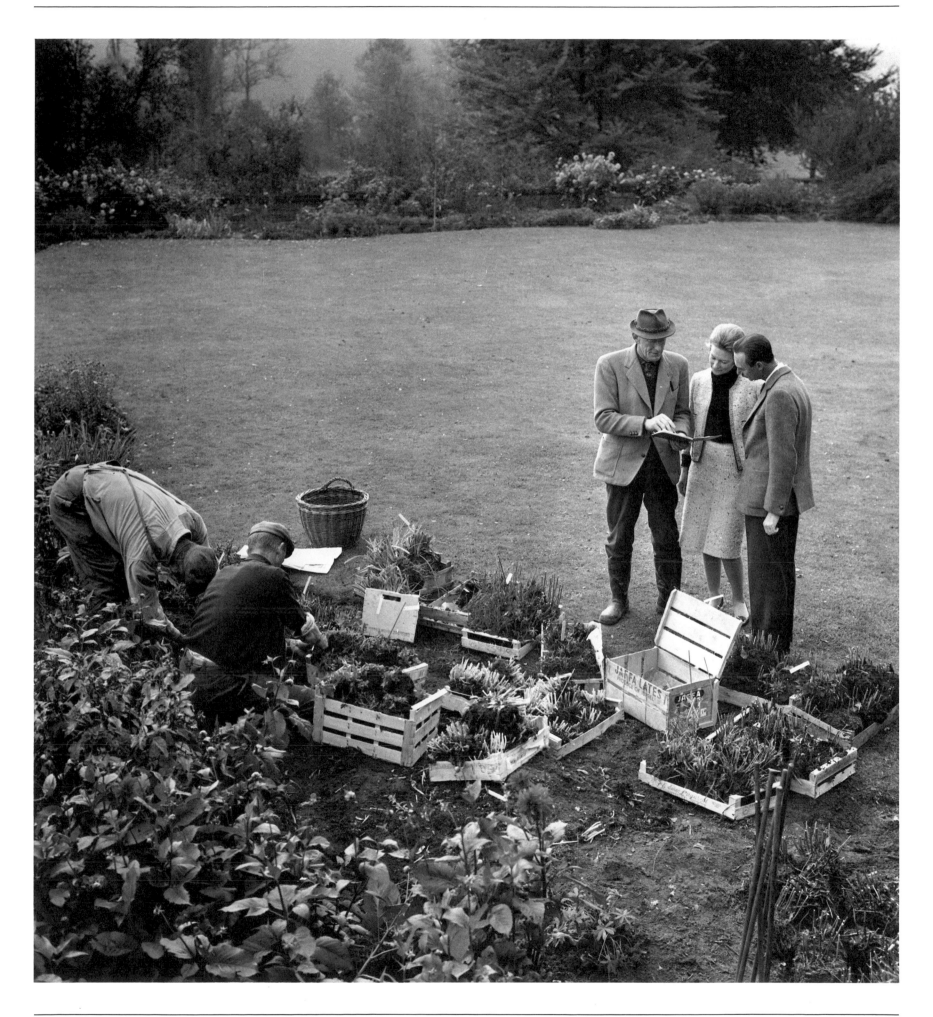

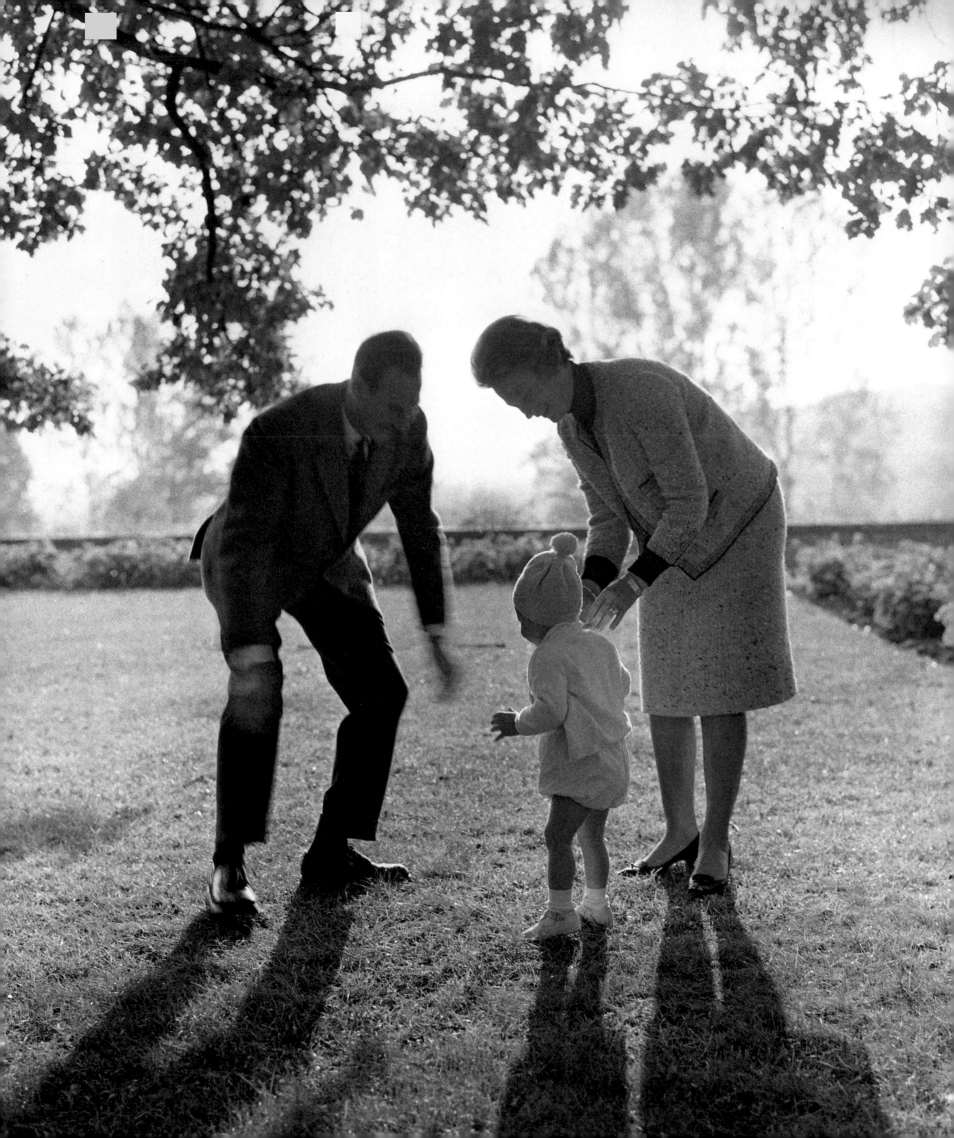

Princess Marie-Astrid.

The Grand Duke and Duchess with their youngest son, Prince Guillaume.

Overleaf:
Grand Duchess Joséphine-Charlotte photographing her husband in the grounds of their home.

THE BRITISH ROYAL FAMILY

The Duke and Duchess of Windsor

Meeting the Duke of Windsor for the first time was a remarkable experience. Here was a man who had once been King and who now seemed just a rather lonely old man, sitting in his house in France, watching the English play football on television. The commission, the first from American Vogue, had come out of the blue. I happened to be in Paris when I received a telephone call from the magazine's legendary and indomitable editor, Diana Vreeland, asking me to go down to the Duke and Duchess's country house – Le Moulin de Tuilleries – and see if I could come up with some unusual photographs.

Conscious that a possible contract with Vogue lay in the balance, it was with some trepidation that I set out for Gif-sur-Yvette. And the first part of the session did nothing to allay my fears.

I had forgotten temporarily that my arrival coincided with the day when England played Germany in the world cup final. When I reached the Moulin the Duke was much more interested in the match than in taking photographs and stayed firmly glued to the set.

There was more delay and distraction after the match had finished too. The Duke remembered that I had once been in the Grenadier Guards and before I fully realised what was happening I found myself, sword in hand, marching with him up and down the lawn doing regimental sword drill.

Eventually we got down to the matter in hand and I began the shooting.

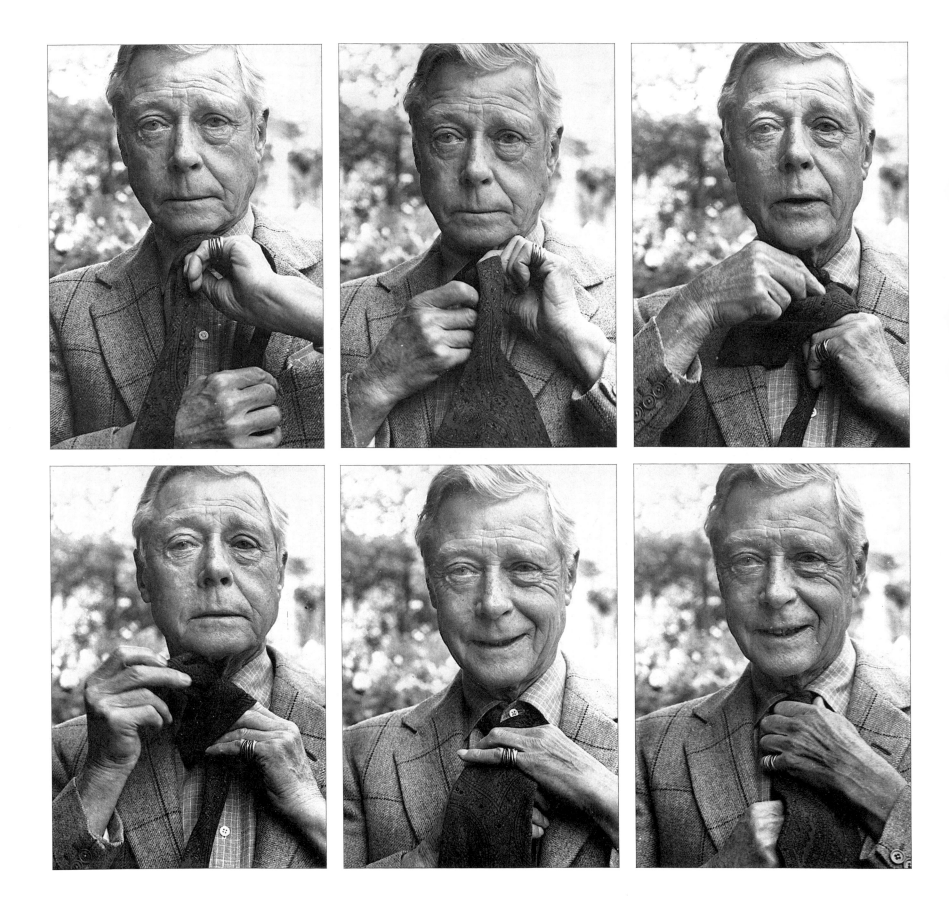

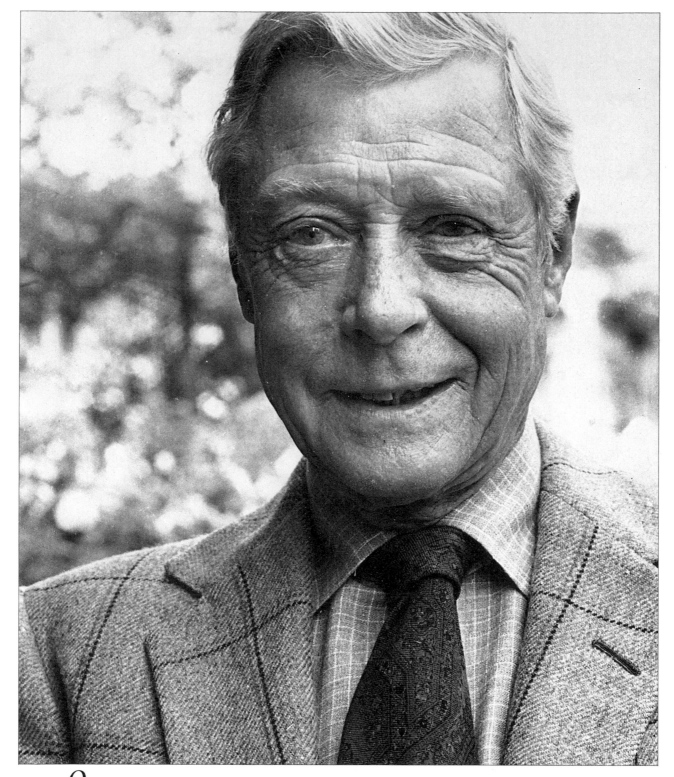

*O*ne of the things that has always intrigued me was the Windsor knot – a way of
tying a tie said to have been pioneered by the Duke when he was Prince of Wales and
a leader of fashion. When I asked him about it he admitted quite openly that he had
invented nothing of the sort. It was simply that he preferred his ties cut a little wider
and lined with thicker silk which gave the impression of a fatter knot. It was other
people, believing that he had found a new technique, who simulated the effect with a
complex series of twists and folds.

Still, here was a fresh angle and I persuaded the Duke to demonstrate for the camera
how he tied his famous knot and, as he had said, he did it in the normal way like
anyone else.

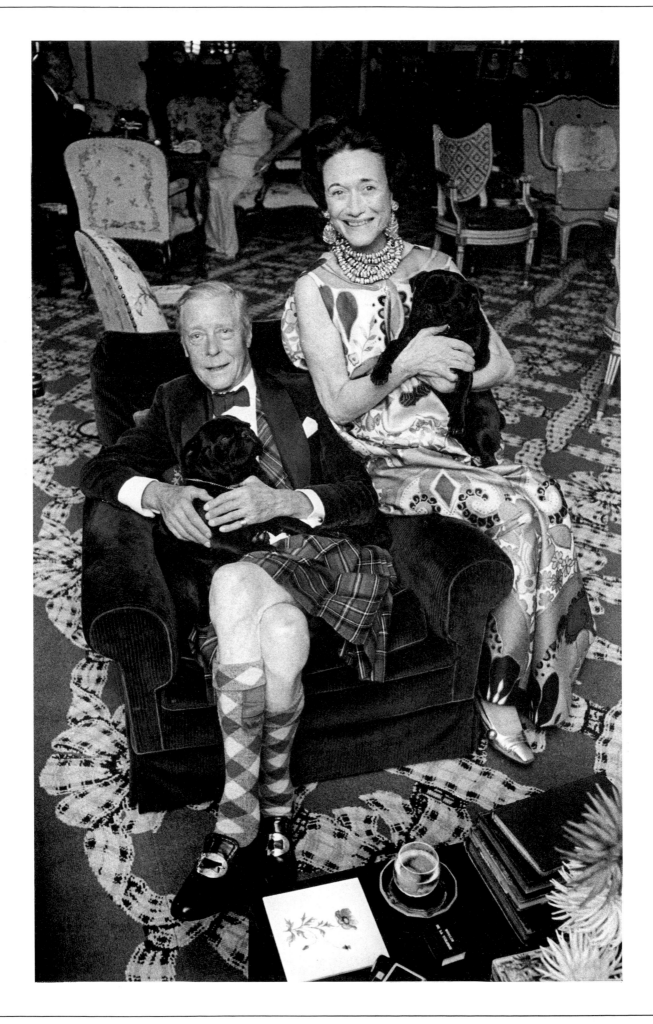

In the evening I took this shot of the Duke and Duchess in their sitting-room with their dogs. The Duke's kilt struck me as a little incongruous in the depths of France but they both look happy and relaxed, perhaps because of something that had happened ealier in the afternoon.

I had posed the Duke and Duchess, with their pugs, under a tree in their utterly enchanting garden but, try as I might, I could not get them to look relaxed. The more I urged them to smile, the stiffer they became.

I was on the point of giving up when, with a resounding crack, my feet plummeted through the garden seat I was perched upon and I found myself up to my knees in shattered cane. The Duke and Duchess thought it was the funniest thing they had seen in ages and could not stop laughing. See photograph overleaf. Shackled though I was, I kept on shooting and those photographs marked the beginning of my career with American Vogue.

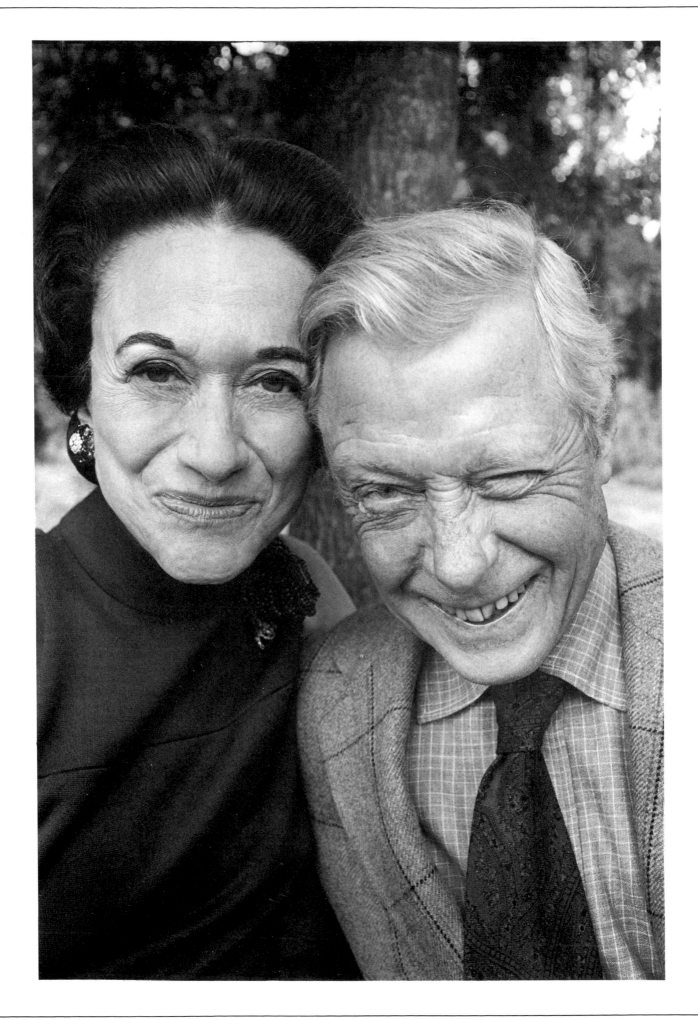

The Duke and Duchess of Kent

*T*he first time I ever photographed any members of the British royal family was a nightmare – calculated, you might think to put a photographer off his chosen profession for life.

I had been commissioned to do some pictures of the Duke and Duchess of Kent with their two elder children, the Earl of St Andrews, and Lady Helen, who was still very young. The session was to take place at their Buckinghamshire home, near Iver. Obviously, I was extremely anxious to make a success of the job and my assistant and I checked and double checked everything, thoroughly we thought, to make completely sure that nothing could go wrong.

So it was with a feeling of quiet confidence that I arrived at the house, set up the lights and prepared to shoot. The hairdresser finished doing the Duchess's hair, the nanny finished preparing the children and I placed them in a simple straightforward pose.

I walked back to take my camera from my assistant but he refused to give it to me. Perplexed by his odd behaviour, I asked what on earth was the matter but he kept muttering, 'I've got something rather important to tell you.' I was becoming rather impatient with all this hushed whispering when he suddenly blurted out, 'We forgot the film.'

Total disaster. Although I am sure that the Duke of Kent could see our confusion and knew what was going on, I had to lie through my teeth and suggest that I should go down to the village for some stronger fuses to avoid blowing all the lights in the house. I leapt into my car and tore down to the village. Of course it was early closing day, as it was, I found, in Uxbridge and Slough. Finally, I found a chemist open for prescriptions only and dived in for £5 worth of film.

The Duke and Duchess were wonderfully patient and when I got back I found them just where I had left them. Quickly I took the pictures and left, breathing sighs of relief.

This, though, was not the end of the story, worse was to come. When I started developing the film, I could not believe how ghastly the photographs were. The poses looked unimaginative and dull, and it looked as though something might well have been wrong with the film I had bought. Each one seemed more terrible than the last and panic began to set in. I thought to myself, 'I'll never get another job if I don't do this one properly', so, summoning my dwindling reserves of courage, I rang the Duke and Duchess and explained that the photographs had just not worked.

They were very understanding and said I could come down two days later and do the shots again. And, thank heavens, this time they worked out all right.

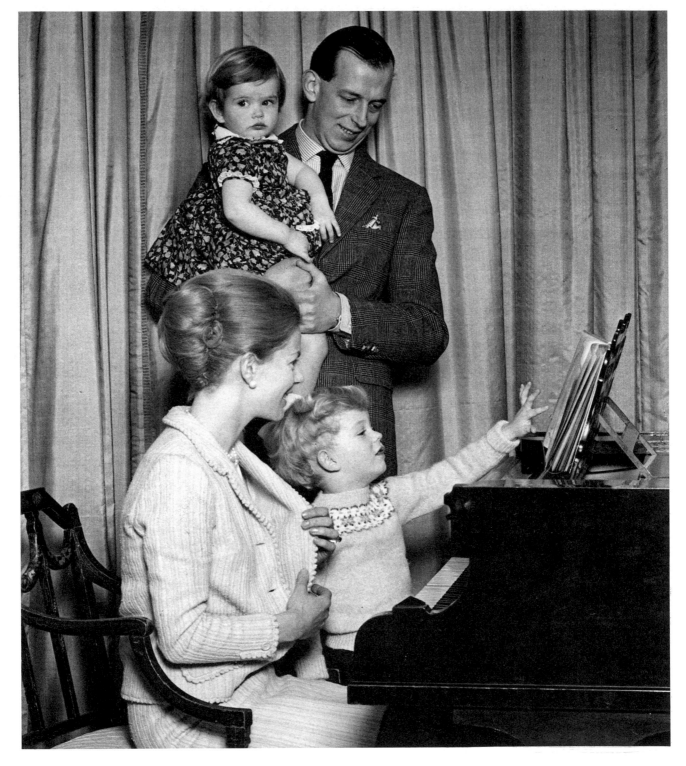

The Duke and Duchess with the Earl of St Andrews and Lady Helen seated at their piano.

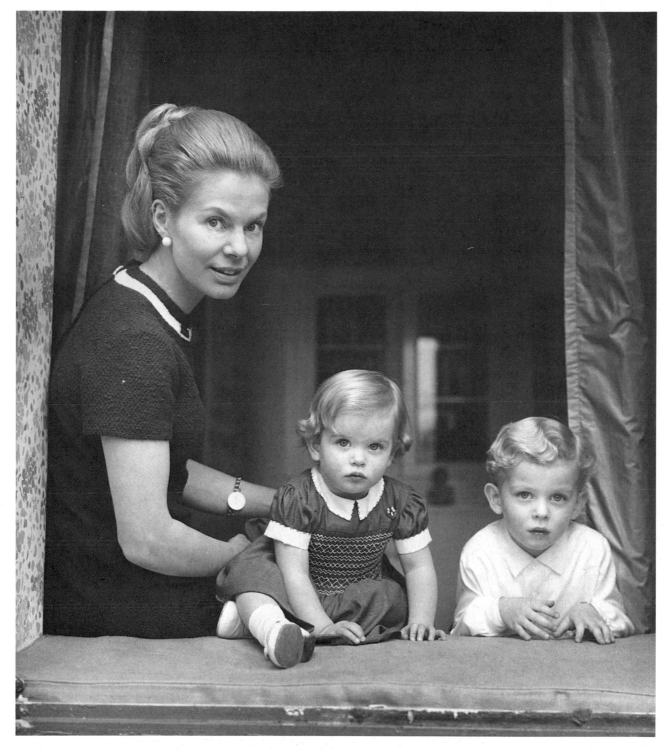

The Duchess of Kent with the two children.

Princess Alexandra and her family

This section on Princess Alexandra and her family begins with two earlier shots of them of which I am particularly fond. Opposite the Princess with her husband and two children, James and Marina, are shown framed in a stable door with a horse, whose expression defies adequate description. A photograph taken in 1974.
Below the family are walking in Richmond Park.

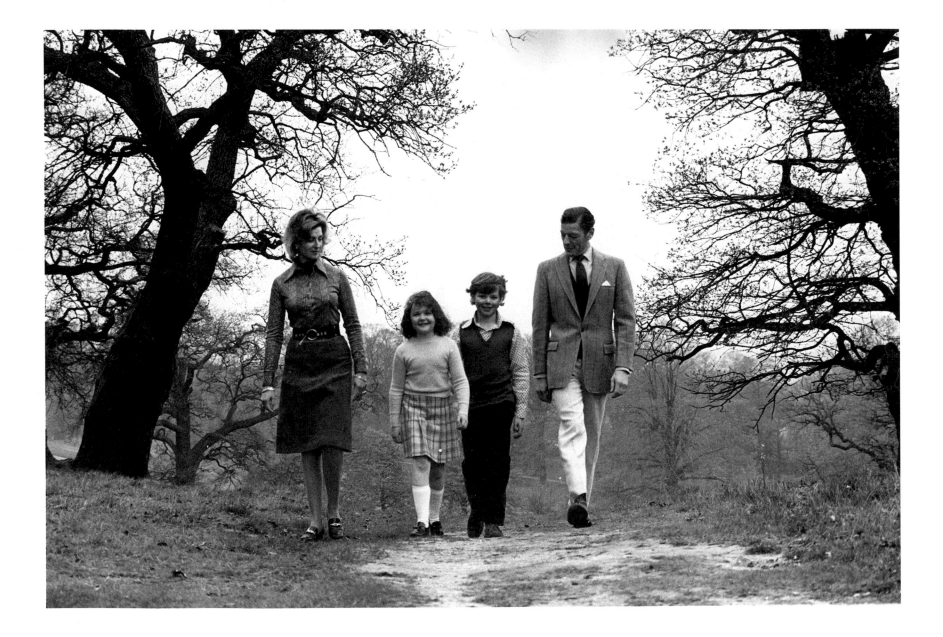

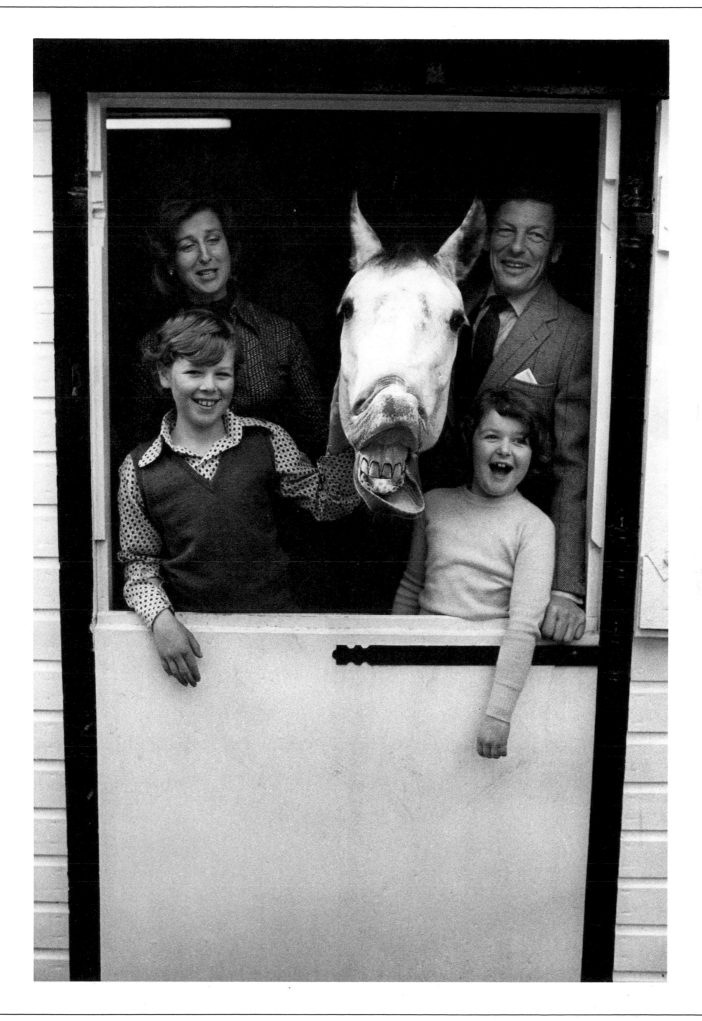

There are a number of reasons why members of the royal family need to be photographed so often and in such a variety of ways. Some pictures are required to give as signed portraits when they go overseas on royal tours, others are needed for release to newspapers and magazines to mark a birthday or some other anniversary and still more are requested by organisations and societies when they receive royal patronage.

Many of my commissions for the royal family have been prompted by such circumstances and I have learnt to ask for fairly lengthy sessions because I am aware of the number of different kinds of photograph which will be needed.

A typical example was when I went down to Thatched House Lodge in Richmond Park to photograph Princess Alexandra and her family in the spring of 1980. The Princess was due to tour Australia shortly and a lot of photographs were wanted. I had been asked to show the Princess in evening dress, in formal, semi-formal and informal settings, and with and without her family. Head shots, family groups and individual photographs of the children were required as well as a special picture to be used as her Christmas card.

The formal shots were quite straightforward, see pages 94, 95 and 96. The two family groups on the other hand illustrate clearly how different you can make people look in a short space of time and very nearly in the same location. The semi-formal group, page 97, was taken on the terrace overlooking the garden when I placed them on some steps above a lavender bush. The informal group opposite was taken only a short time later in bracken a few yards away. This photograph was meant to look like Scotland which is why Angus Ogilvy has changed into a kilt.

Princess Alexandra is very welcoming and hospitable, and funny, and we all seemed to spend our time in fits of laughter. This posed problems for me because, unless I could get them to be serious for a moment, I knew I would end up with a large amount of unusable pictures.

In spite of their good humour neither Princess Alexandra nor Angus Ogilvy particularly enjoy being photographed and so they are best taken in their own setting where they relax as much as possible. Having been photographed myself, I know that it is much easier in your own home than sitting in a studio with lights popping at you. I was quite pleased with these photographs as I hope they were. Princess Alexandra seems to think she is not very photogenic but I totally disagree – she has fine distinguished features that photograph with grace and charm.

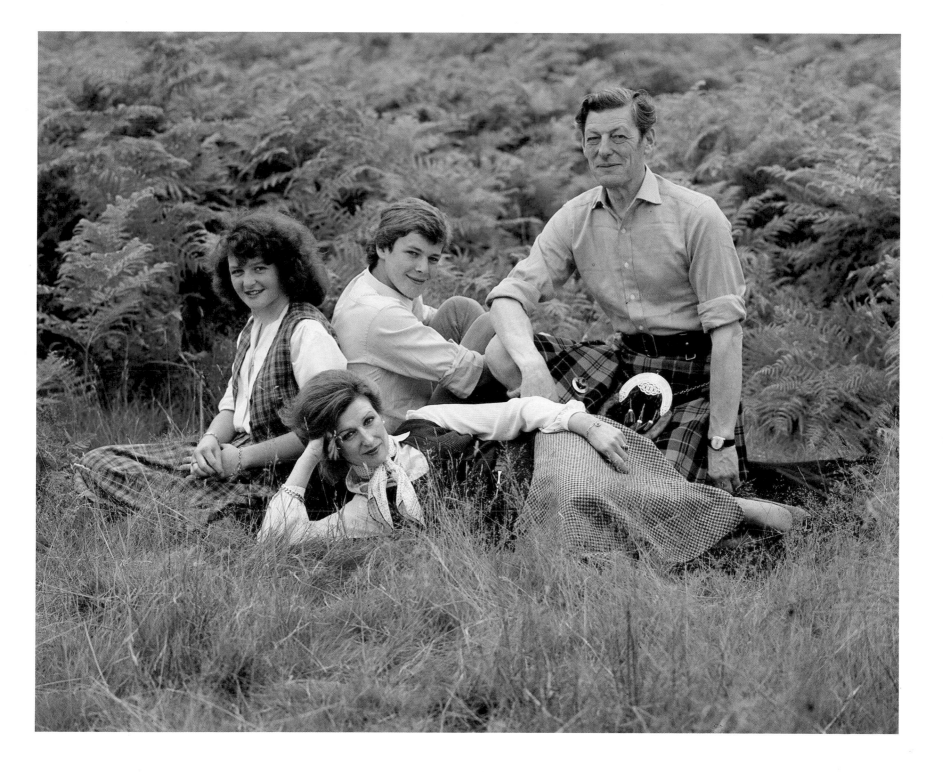

Two formal portraits of Princess Alexandra.

Princess Alexandra with her husband, the Hon. Angus Ogilvý.

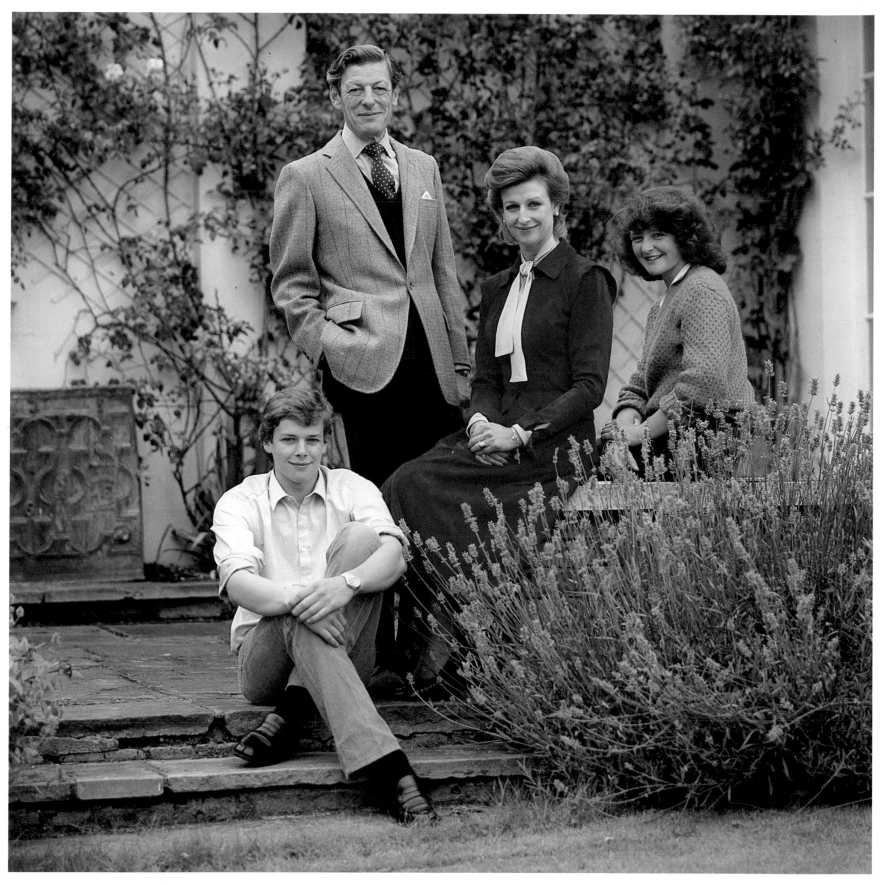

The semi-formal family group on the terrace.

Princess Margaret and her family

Princess Margaret loves the world of the arts. An accomplished pianist and singer, she dances beautifully and has an uncanny gift for mimicry which makes her a welcome asset at any party. The first time I ever saw her, she was playing in a pantomime at Windsor Castle and I know that as a young girl she often entertained her father, King George VI, at the piano after dinner. Her marriage to Lord Snowdon brought her into even closer contact with the artistic milieu in which she has always felt perfectly at home.

Like many other people she is fascinated by the famous and enjoys the excitement of their company. The wedding of Sharon Cazalet and Simon Hornby at Fairlawn in Sussex was just such a star-studded occasion. The bride was a great friend of Elizabeth Taylor and the guest list was liberally sprinkled with famous names – Noel Coward, Richard Burton and Sir John Betjeman among them.

I had fun photographing the big groups, particularly with Elizabeth Taylor who kept pulling crazy faces. I had just finished and was trying to photograph someone else when I noticed Princess Margaret duck down behind a hedge.

I suspect she though she was going to surprise me – but I was ready for her. As her head popped up, I clicked the shutter and got a snap which, I think, shows her great sense of fun and captures her looking really happy.

I like the fashion element in this shot. It was taken in 1968 but even today the morning coat in the background would be just the same – the mini-skirt though, looks very strange at this distance in time.

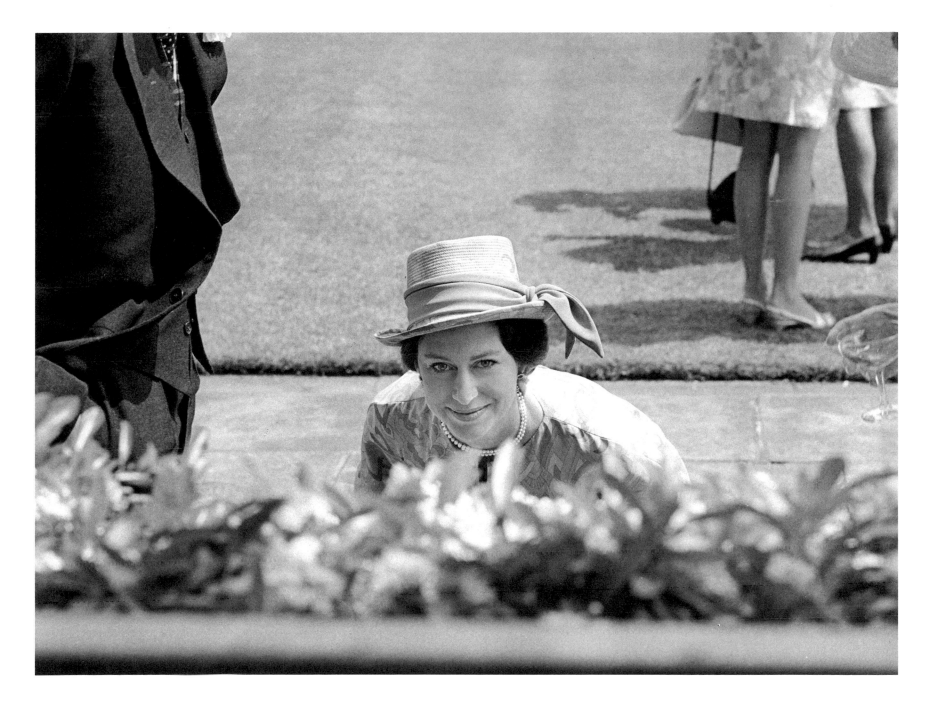

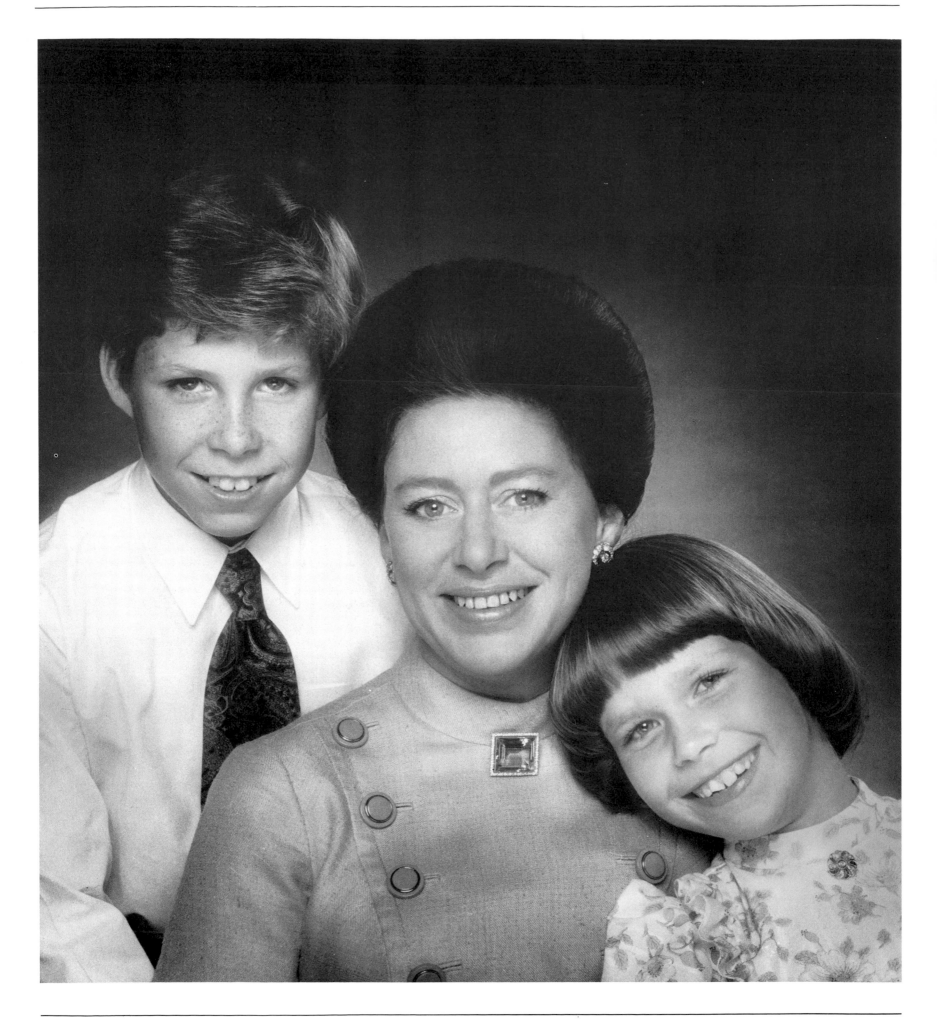

As a rule children are a lot easier to photograph than adults. As long as you don't talk down to them their unselfconsciousness and natural charm are a great help to the photographer.

I started by career as a children's photographer and did an enormous amount of it. Lord Snowdon also began his career that way and took some incredible shots of children – probably the best since Marcus Adams.

Having children in a group photograph alters your whole approach to the task. One of the tricks is to address all your remarks to the youngest child pesent – even when doing a group where most of the line-up are adult. For some reason the grown-ups will respond just as well as the child and the battle's almost won.

Royal children, though, are special. Even at at relatively early age they are used to the camera because every year they have to go through the business of posing for an official photograph. Thus by the time I came to take this picture of Princess Margaret and her two children, Viscount Linley and Lady Sarah Armstrong-Jones, they were really quite sophisticated about it. Of course they did have the added advantage of a professional photographer for a father.

Everyone has heard of Mustique, the tiny island of the Lesser Antilles close to Barbados. It appears in all the travel brochures as a sort of mecca for the rich, full of jet-set holiday homes. Princess Margaret has a house there as does Mick Jagger and the owner of American Harpers.

Despite its image though, there is nothing ritzy or extravagant about life on Mustique. On the contrary, it is a very simple and unpretentious island where jet-set people go to get away from jet-set life. It is a fascinating chip of the West Indies with a very strong West Indian flavour and a sizeable indigenous population.

Like many people I love the idea of island life and have looked around many islands all over the world, but I've come to the conclusion that Mustique would take a lot of beating. I first went there in 1967 where there was only one house on the island apart from the little fishing village – and I have been going there every year since.

In those earlier days we always used to have to go by sea from the mainland, a nightmare journey because of the fiendish screw current which always made for a rough crossing and a boatload of green-looking, miserable passengers. Now it is just a short twenty-minute hop in an Islander 'plane.

I am often asked what there is to do on an island that is only two miles long and one mile wide. In fact there is a great deal to do, particularly if you have a house there.

People are beginning to take gardening quite seriously and of course there are the wonderful beaches and every kind of water sport imaginable. Many houses now have live-in cooks who get better and better, so most people tend to eat at home but if you want variety there is the Cotton House or the beach bar on the seashore.

Princess Margaret was one of the first people to build a house on Mustique. She was given ten acres of land on the south side by her old friend Colin Tennant, the island's owner. Her bungalow is quite isolated and affords her a degree of privacy that would be hard to find elsewhere. On the island she can wander about freely – of course, everyone knows her, but where else would she know everyone? The Queen and Prince Philip took advantage of their proximity to the island during their Caribbean tour in Jubilee year to spend a day with the Princess on Mustique.

Opposite: Princess Margaret arrives at a beach party to celebrate the Hon. Colin Tennant's birthday party.

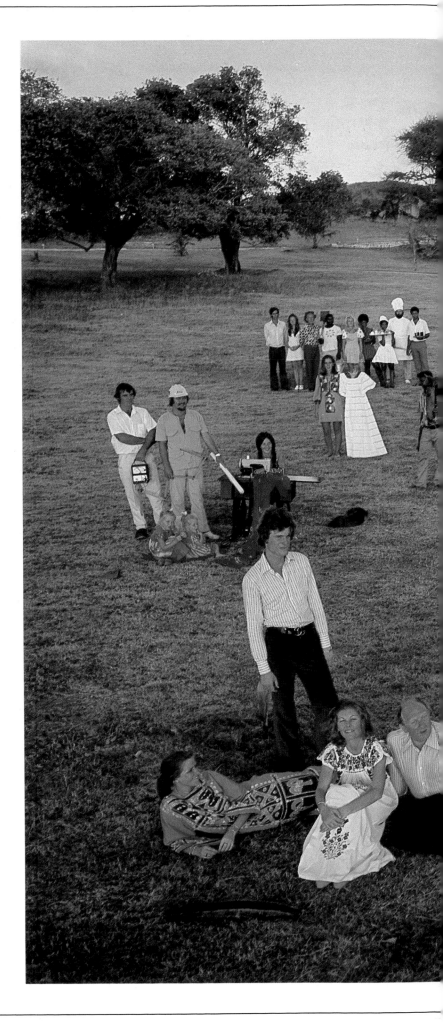

*W*hile I was holidaying there some years ago I came up with the mad idea of trying to photograph all the residents of the island together. It was great fun to arrange, if rather hectic, and I had to climb a tree in order to get the shot.

But in the photograph there they all are: everyone from the Princess and her houseparty, Colin Tennant (centre) and his friends, the managing director of the island and his assistants to the fishermen with their nets, the groom with his horses and the lady with her sewing machine. I even managed to include the island's only aeroplane.

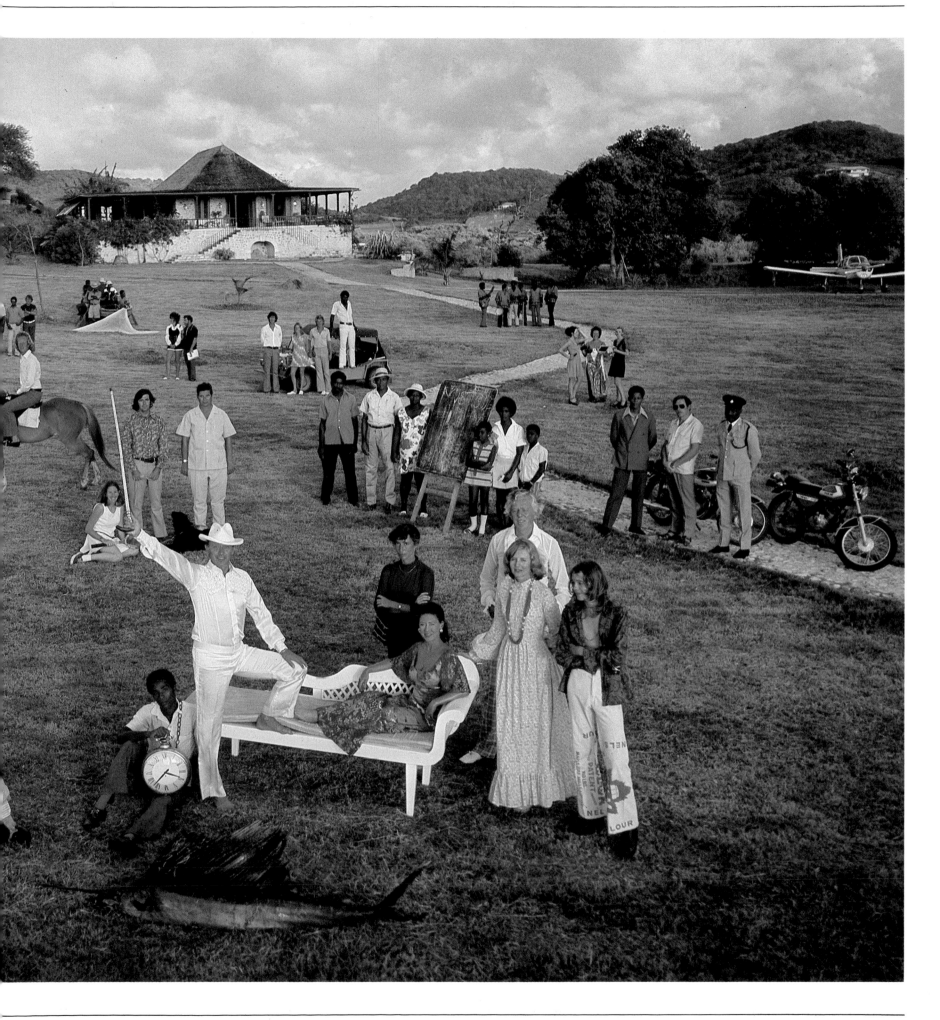

Princess Anne and her family

I particularly like working for the Post Office because they go to infinite trouble over design to ensure that the pictures used look as good as possible. I was therefore delighted when they commissioned me to take an engagement photograph of Princess Anne and Captain Mark Phillips to be used on a stamp that would be issued on their wedding day.

For some strange reason Britain is the only country in the world where the stamps do not bear the name of the country, so the picture had to fill the entire oblong shape of the stamp. I decided the best place for the session was on the east terrace at Windsor Castle in the formal gardens. The Princess and Captain Phillips were both in very good form and the session took only a matter of minutes. My only difficulty was trying to catch them when they were not laughing too much.

I was rather pleased to be associated with the Post Office even to this extent as my family title was up-graded from a Viscountcy to an Earldom in 1831 because of my great-grandfather's appointment as Postmaster General. He and the Shropshire schoolmaster, Roland Hill, together introduced the penny post and set up the postal service. Nearly 150 years later I ran my own private post during the strike of 1971 and some of my stamps are in the royal collection.

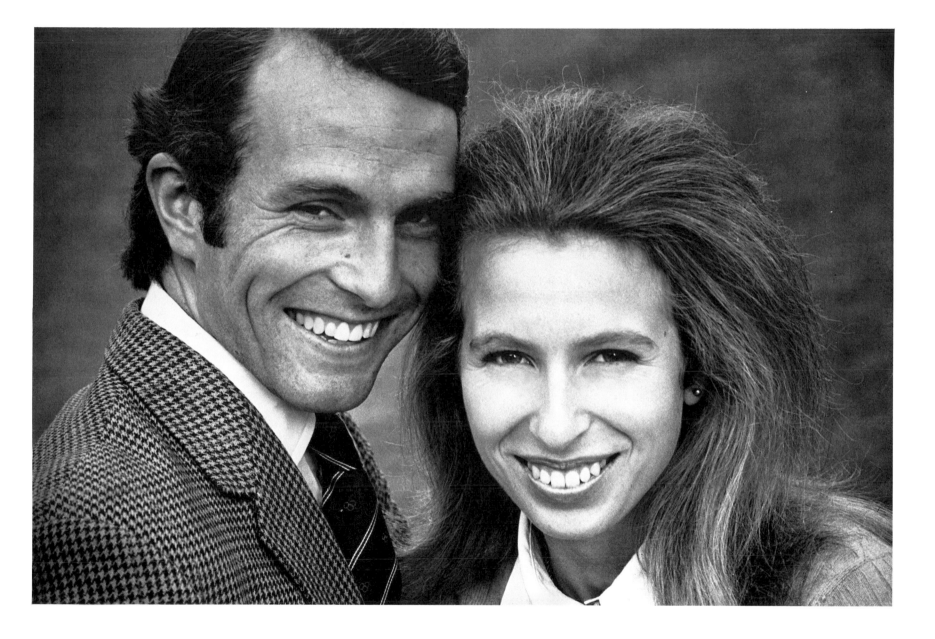

Unless you are actually vain, being photographed is not a particularly comfortable or enjoyable experience. No one, not even the most practised sitter, likes hanging about while the photographer fiddles endlessly with the lighting or the exposures – not even models who earn a living that way. So if you can be quick, without of course sacrificing quality, you will avoid that wooden look that settles on a bored sitter's face.

Cecil Beaton once told me that if you do not get it right in the first two rolls of film, you might as well pack up and try again another day.

Sometimes a lot of elements will conspire against you and if your confidence begins to ebb it's certain that your photographs will not create the effect you set out to achieve.

But provided you have got it right then speed is essential. When taking double head portraits it may take a little time to place the heads as you wish because, to be in the frame, the sitters have to be posed uncomfortably close together, but thereafter all you have to worry about are the facial expressions. Then you pray to God and the lab that the exposure is right.

One of the more frustrating things about taking double head shots is that though it would be very useful to take a few polaroid shots beforehand to ensure everything looks right, it is simply not possible. With your sitters poised on one leg or leaning at awkward angles you cannot really expect them to wait around for sixty seconds while the polaroids develop. So what tends to happen is that you carry on regardless, leaving those polaroids that you have taken to cook and only when the session is over do you have time to peel off the top layer and, hopefully, breathe a sigh of relief when the picture is more or less as you wanted it.

Over the years I have worked for most London newspapers which has taught me to work fast. I have deliberately tried to avoid becoming the kind of photographer who carefully stages everything, as I think a degree of versatility is essential. I hope that this book illustrates this for included here are many carefully planned and posed photographs alongside others which are simple, unpremeditated snaps.

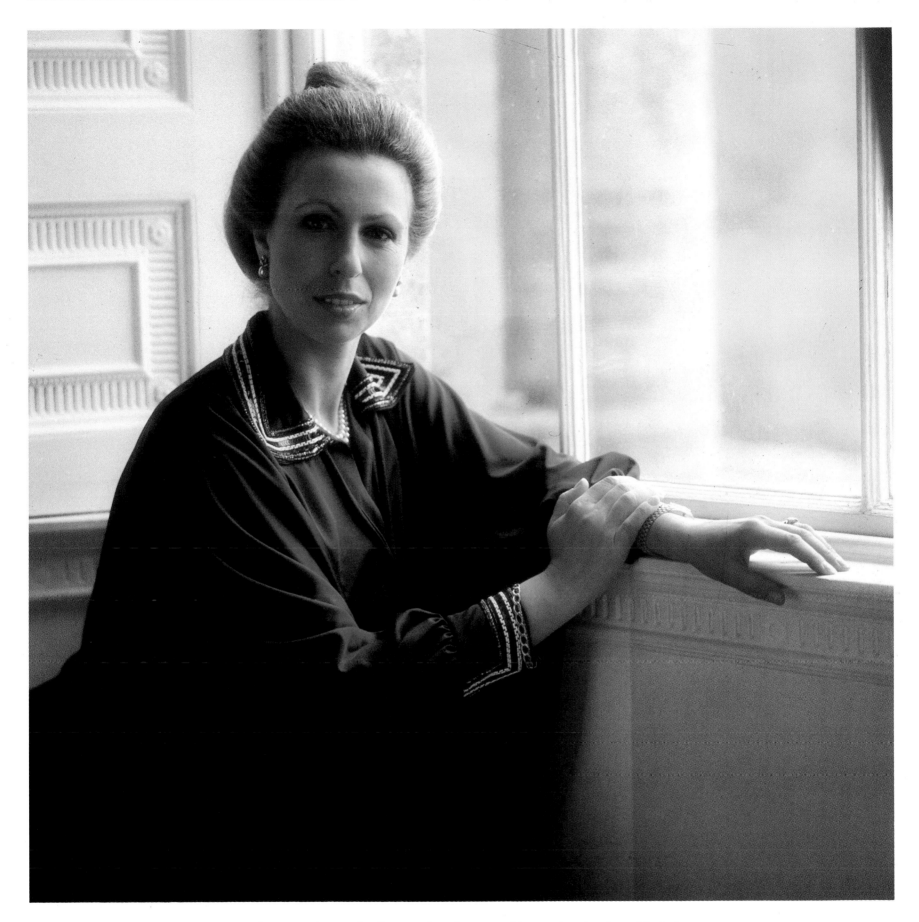

Indoors at Gatcombe during the photographic session for her thirtieth birthday.

A simple studio portait of Princess Anne in 1973.

An informal study of the Princess taken at Balmoral.

When doing the series of pictures for Princess Anne's thirtieth birthday in 1980 I took some formal shots of her walking in the garden. This was one of those occasions when by habit of just keeping-on-shooting once a session begins, resulted in a rather less formal shot than I had intended. Events can change the most stately of shoots and, this time, it started to pour with rain. Princess Anne's hairdresser had spent hours doing her hair so beautifully and his dismay can be imagined. So this uncropped shot shows his hand holding an umbrella over the Princess's head while she poses regally beneath.

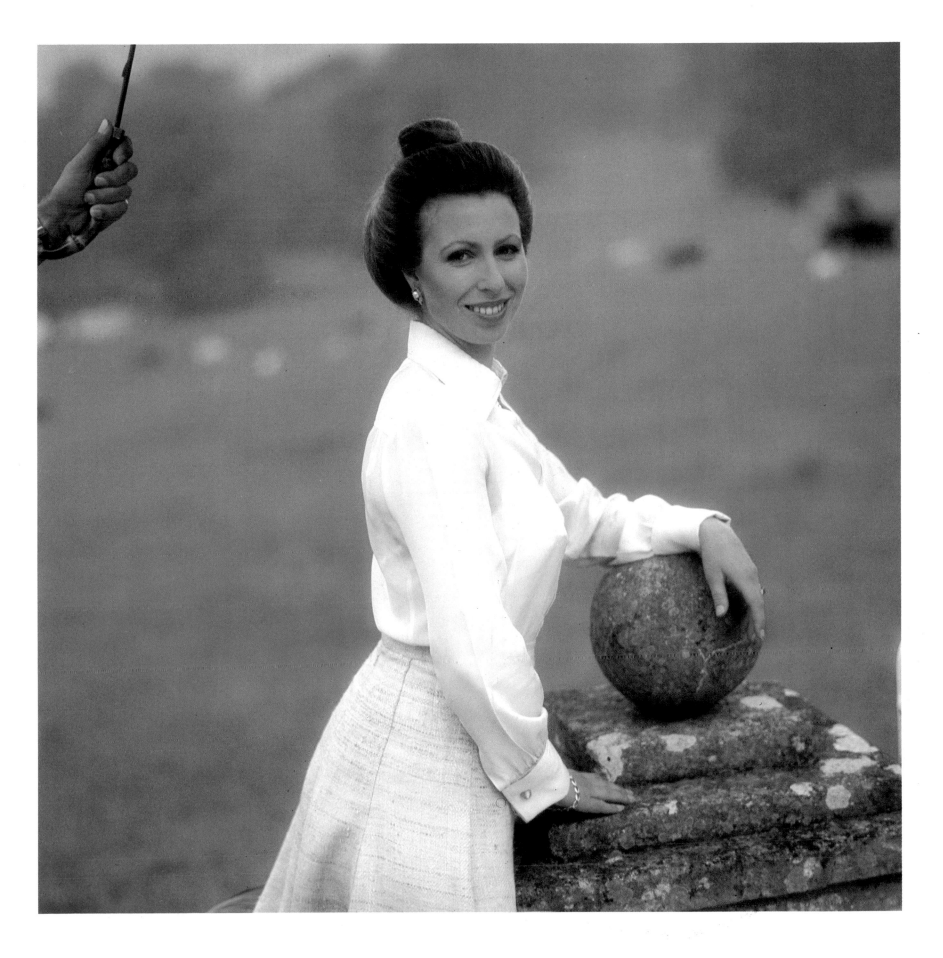

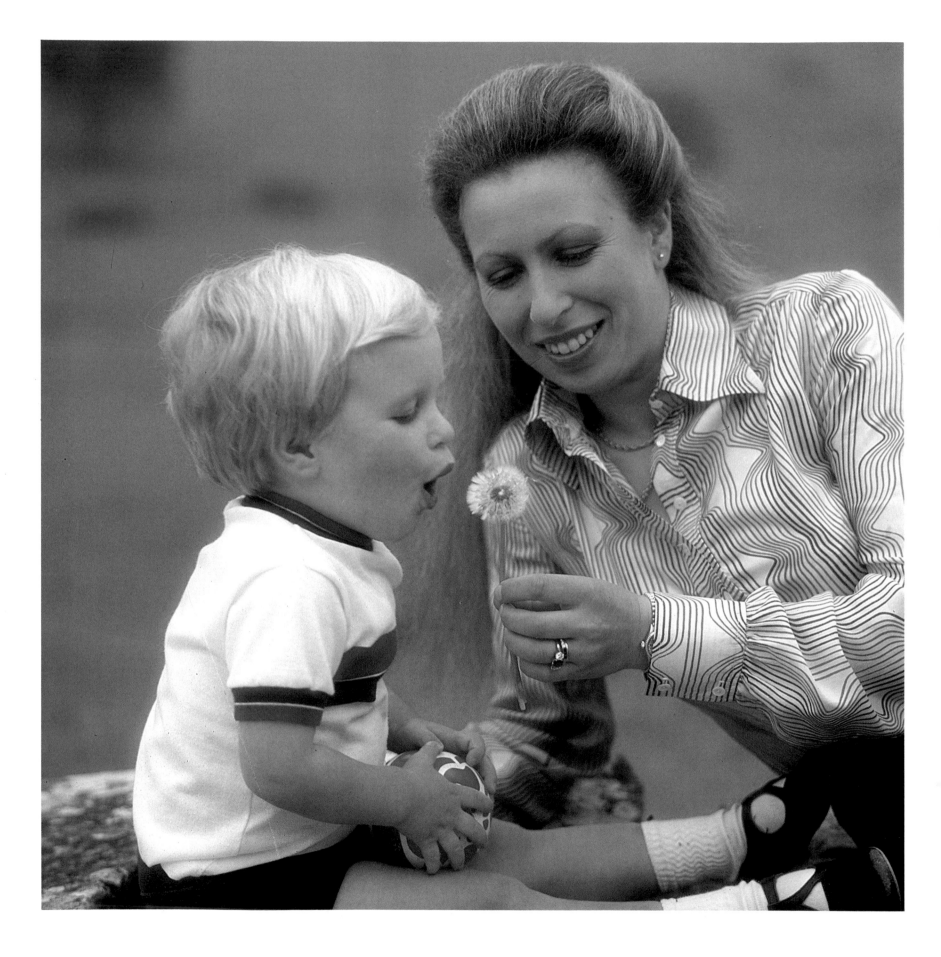

When I was commissioned to take a series of photographs to be issued
on Princess Anne's thirtieth birthday I took care to include all her family.
I have found with such commissions that newspaper and magazine editors
are very disappointed if the children of the family are not included in the
photographs, however small they may be, so for the first time the
Princess's son, Master Peter Phillips, had to be featured.

Master Peter was only two years old and one of the difficulties with a
toddler is to try to find a visual link between the mother and child which
involves the baby. In my view cuddling pictures are very nice but they can
be overdone.

I came up with the suggestion that we should find a dandelion clock,
which the Princess could hold while Master Peter blew. Easy you'd think,
but by some freak of nature or because Captain Phillips is such an
excellent farmer, we could find only one dandelion on the whole place.
We carefully sprayed the precious dandelion with hair lacquer to stop the
fluff all coming off with one blow and, luckily, the ploy worked.

Two days before the wedding of the Prince and Princess of Wales I was fortunate enough to be asked to photograph the christening of Princess Anne's baby daughter, Miss Zara Phillips, at Windsor Castle.

Fully occupied as we were with preparations for the wedding, this commission, although very welcome, was a bit too close to the great day for comfort, and, to add to the problems, a television crew was making a film about the Princess's life and wanted to film the christening as well. The photographs had to be taken just before going in to lunch which gave us very little time to take the number of shots that were required. Ideally too, with babies you need time and patience to coax them into smiles by blowing bubbles or lighting a sparkler or something, but obviously on this occasion such time-consuming measures were out of the question. Although Zara was very good, she took on a look of great severity when I started to peer at her closely through the lens – rather like Kitchener I thought.

I also made the mistake – which is only too evident on the photograph overleaf – of assuming that all sofas are the same height. The Queen's knees were almost touching the ground and Mrs Peter Phillips looks equally uncomfortable. But, despite all the problems, the photographs worked quite well and Princess Anne chose the shot of herself with Zara for her Christmas card.

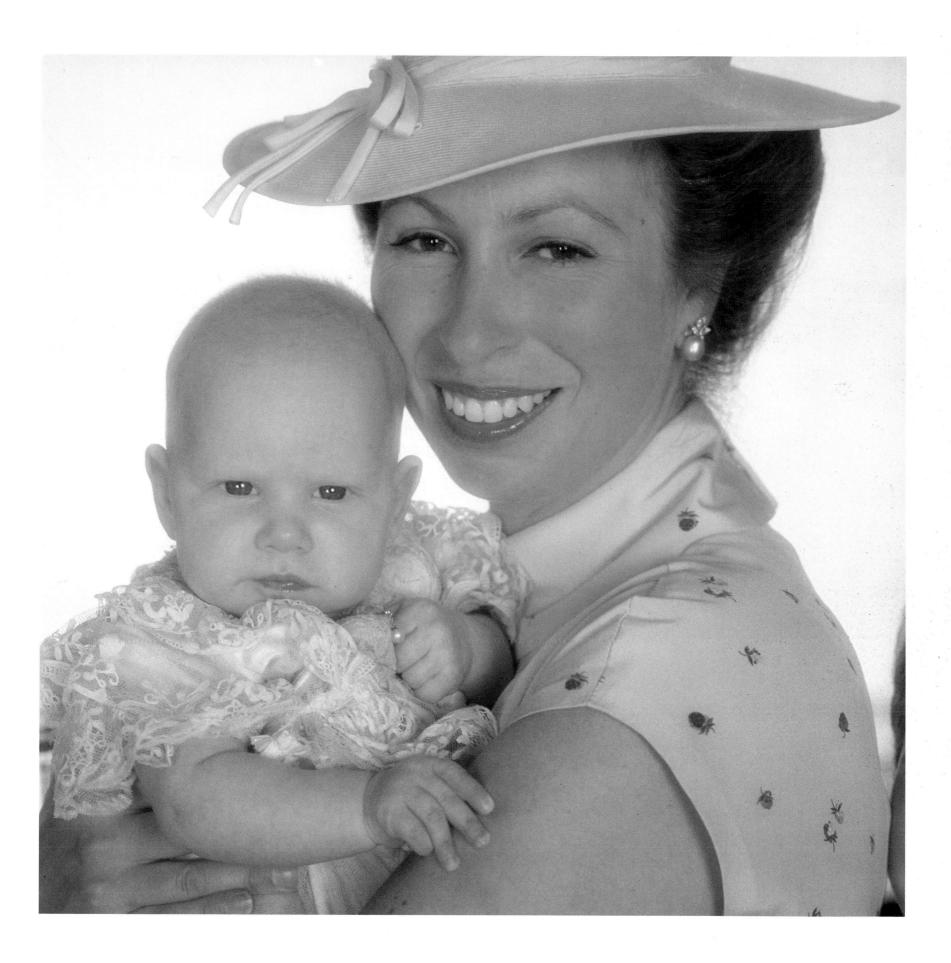

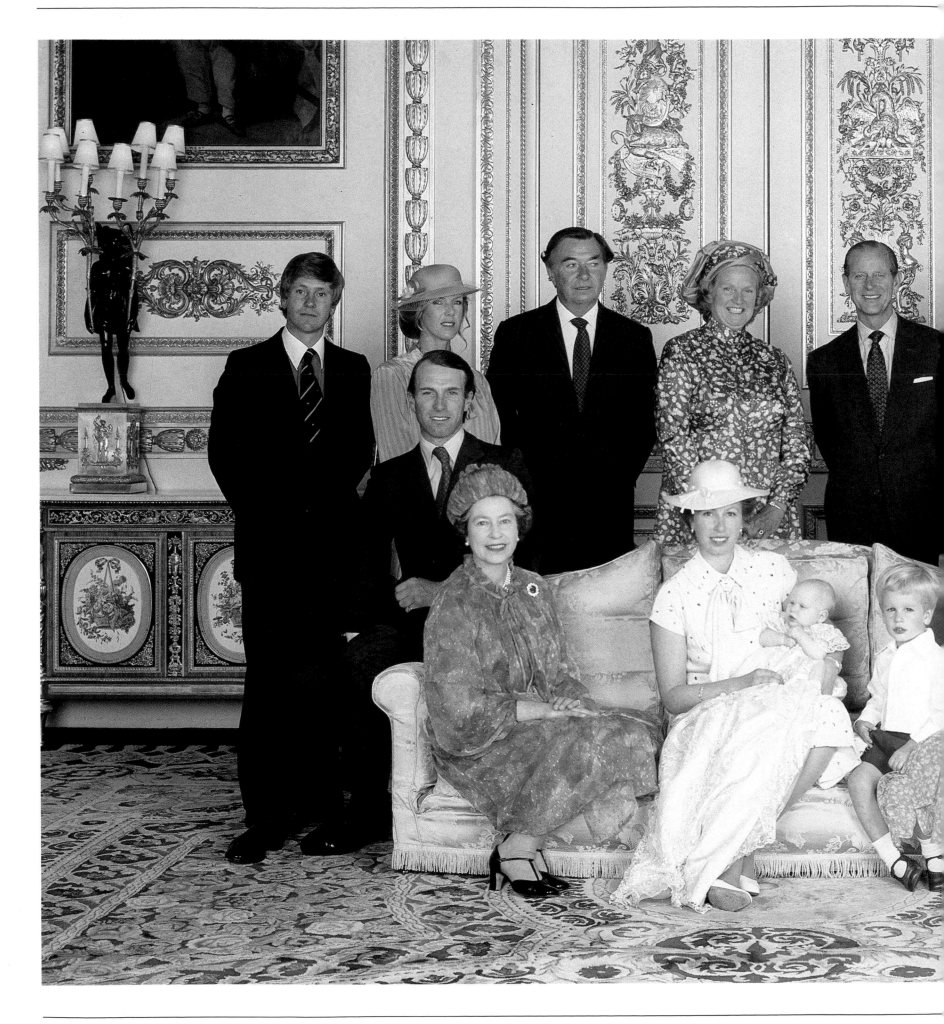

Left to right back row: Mr Hugh Thomas, Helen Stewart,
Mr Phillips, Mrs Phillips, Prince Philip, the Countess of Lichfield,
Col. A. Parker-Bowles
Seated: Captain Mark Phillips, Her Majesty the Queen,
Princess Anne and Zara, Peter Phillips, Queen Elizabeth
the Queen Mother and Prince Andrew.

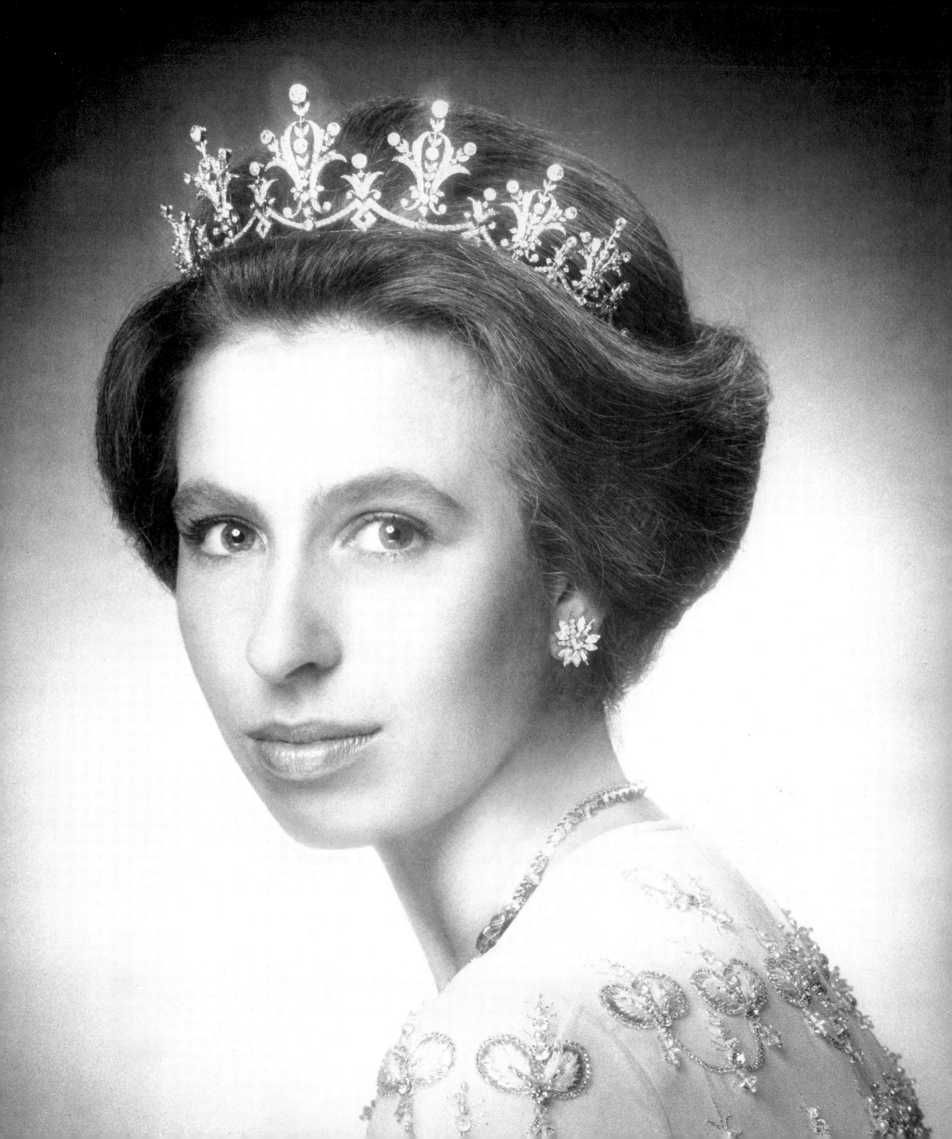

GROUPS AND FORMAL PORTRAITS

However painstakingly you pose a portrait or group portrait the end result is not going to work unless you have established some kind of rhythm. Good portraits depend upon mood and you have to be prepared to waste quite a lot of film, and energy, to achieve the right atmosphere and get the subjects to relax. Normally I do this by drawing attention to myself, by doing stupid things like tripping over accidently or making some other deliberate gaffe, so that people stop worrying about the awkward situation they're in and start to respond to the antics of the photographer. It can be difficult to do convincingly, but it is absolutely vital.

Group photographs pose their own particular problems. It is essential that you keep the group's attention riveted on you while, at the same time, trying to encourage each individual character to come through.

Careful planning and preparation are necessary. Before a session begins you should have a reasonably clear framework in your head of what you are going to do and what you are trying to achieve. Remember that the setting is important. It can reveal totally unexpected hazards or impediments which may need to be eliminated. I have learnt the hard way that it is always worth doing a recce and, now, even if I am going to be working somewhere quite familiar, I always go and have a look first.

Once you have your framework and plan worked out then, paradoxically, you must be prepared, once the session begins, to adapt and alter it as circumstances dictate. Good and bad things can happen in a session and if you are able to turn every situation to your advantage then the end result will be that much more satisfactory.

People tend to be wary of photographers, fearing that they may be asked to do something unnatural that will make them look foolish. This is where a certain amount of diplomacy comes in useful and, more practically a polaroid camera. When trying to persuade people that, however strange what you are doing seems to them, they will be perfectly happy with the result, a polaroid snap, which you can show them as evidence in sixty seconds, makes the argument irrefutable. It can also help with compositions and variations of exposure.

Opposite: Queen Elizabeth, the Queen Mother with Yehudi Menuin and the Chief Rabbi, the Very Reverend Doctor (now Sir) Immanuel Jakobovits, at Westminster Abbey.

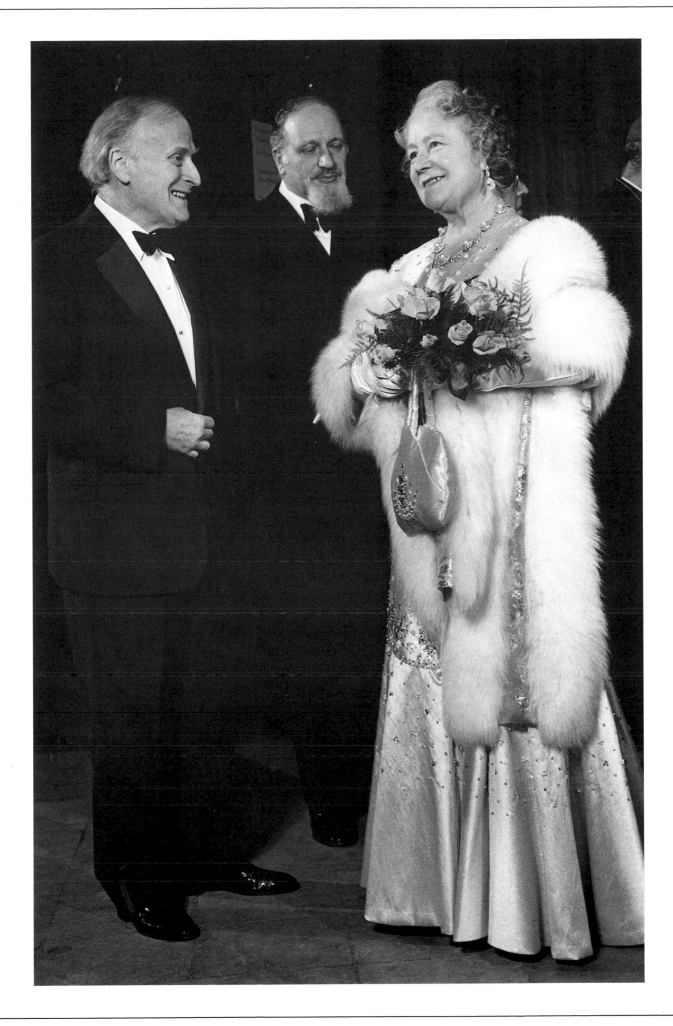

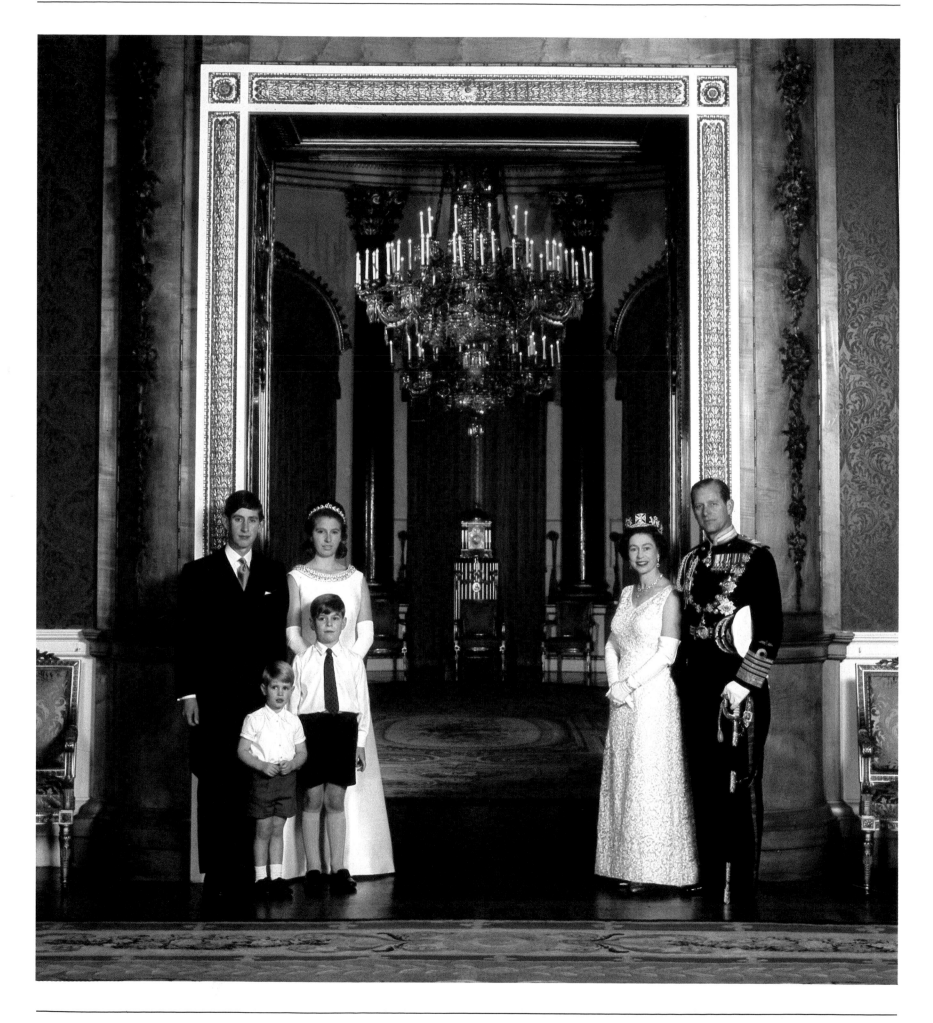

My first ever photograph taken at Buckingham Palace of the Queen and her family before the state opening of Parliament.

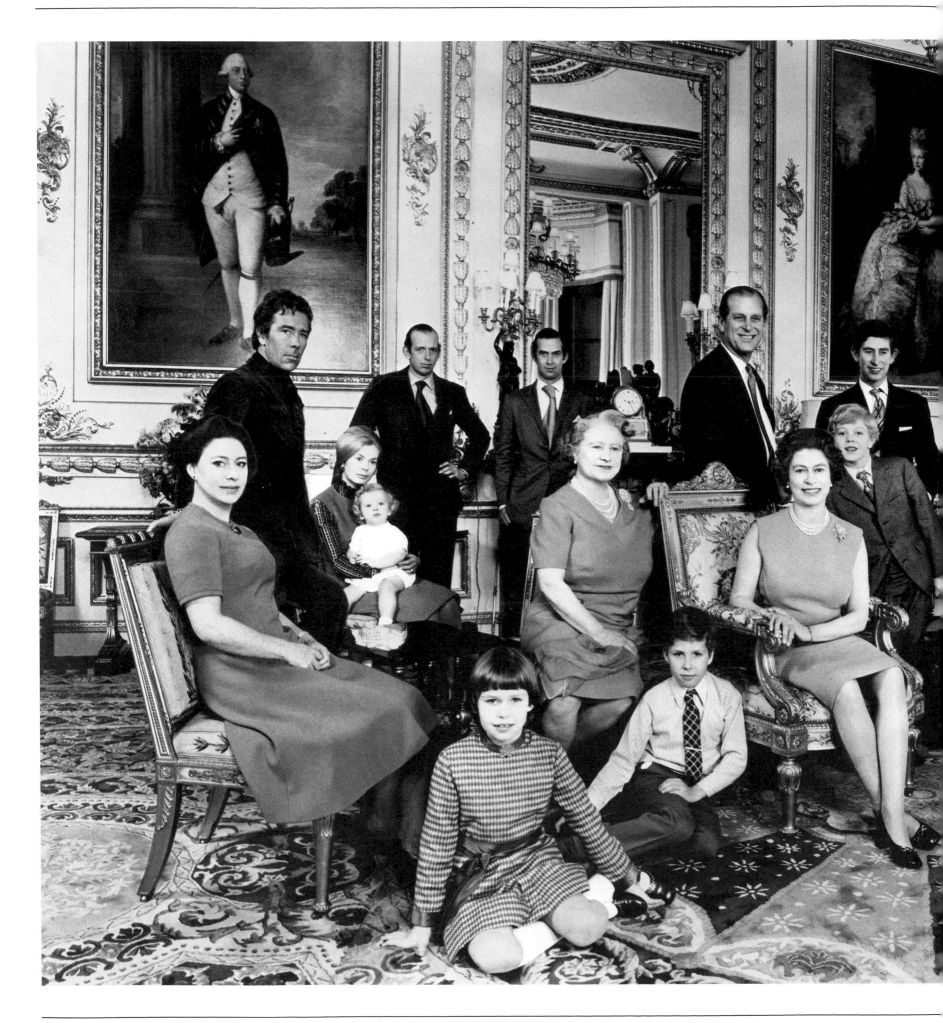

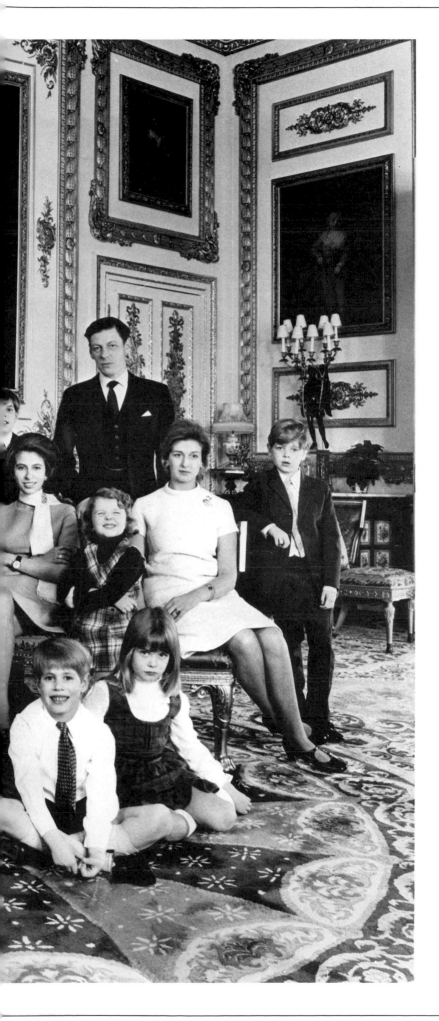

A *painting by Winterhalter and the humour of the Marx brothers were jointly responsible for this picture.*

It was the painting of Queen Victoria surrounded by her large family which first gave me the idea of taking a photograph of the whole royal family. If it could be done in oils a hundred years ago I saw no reason why I could not do it today using film.

Such a project had never been undertaken before and the thought of doing such a big group filled me with trepidation. I was pondering over various ways of organising the session when Lord Snowdon came up with an inspired idea. He had seen the family watching television and suggested that this might be the way to photograph them. And so there they were grouped around the television watching a Marx brothers film and every time a joke was obviously coming up, I pressed the shutter.

The Queen had very kindly asked me to stay at Windsor Castle over Christmas which was a great help as it is about the only time of the year that the whole family are in one place at one time. But the day – Boxing Day 1971 – started badly. The large drawing room we were to have used was undergoing structural repair and I had to squeeze them all in to a much smaller space. Then I managed to fuse all the lights setting up my equipment and, no sooner was that put right, than I found out that someone – and I never discovered who – had swapped round all the place cards carefully laid out before lunch.

I had to take the photographs from the top of a ladder as it was the only way I could fit them all into one lens. I was well into the session when I suddenly noticed that my assistant's head was reflected in the mirror behind them and being faithfully reproduced in the shots.

Then Lord Snowdon came to the rescue again. He suggested that I take three separate shots at floor level as a fail-safe. And thank goodness I took his advice, because it was those three shots, pasted together, that eventually made up the final photograph. I then used the other photographs I had taken to replace the head of any member of the family who did not look right, pasting them carefully in place. So there are probably five heads in the final picture that were not in the original. Perhaps oil painting is easier.

Left to right (back row): The Earl of Snowdon, the Duchess of Kent with Lord Nicholas Windsor, the Duke of Kent, Prince Michael of Kent, Prince Philip, Prince Charles, Prince Andrew, the Hon. Angus Ogilvy.

Left to right (centre row): Princess Margaret, the Queen Mother, Her Majesty the Queen, the Earl of St Andrews, Princess Anne, Marina Ogilvy, Princess Alexandra, James Ogilvy.

Left to right (front row): Lady Sarah Armstrong-Jones, Viscount Linley, Prince Edward, Lady Helen Windsor.

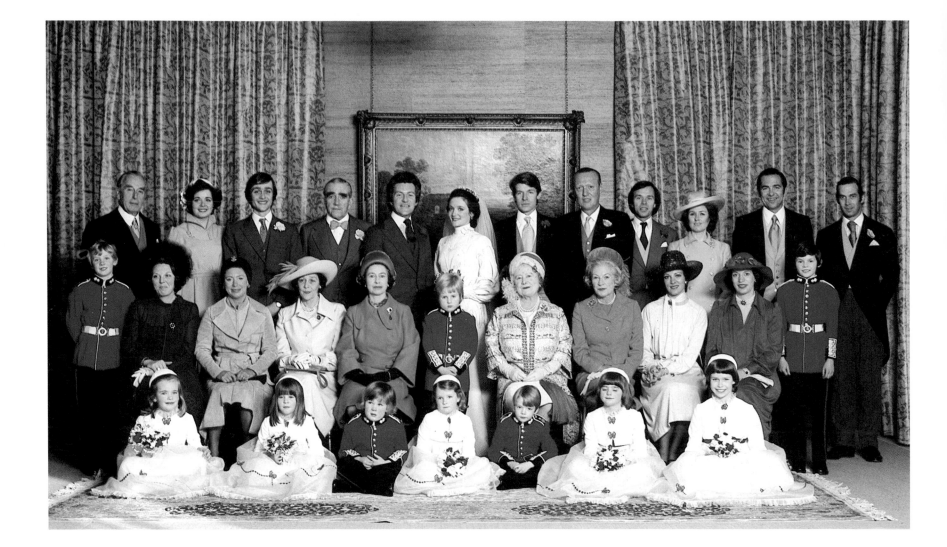

*D*espite all the problems I really quite enjoy doing big groups – in fact I even set up the photographs for my own wedding in 1975 and had my assistant press the button. I organized everything beforehand and the only difficulty that arose was when I had to do all the shouting from the back – at work on my wedding day.
The photographs were taken at my wife's home – Eaton Hall in Cheshire – and the line up is:

Left to right (back row): The Earl Mountbatten of Burma, Lady Jane Grosvenor, The Earl Grosvenor, the Duke of Westminster, the Earl of Lichfield, the Countess of Lichfield, the Hon Brian Alexander (best man), Prince Georg of Denmark, Sir Geoffrey Shakerley, Lady Elizabeth Shakerley, the King of Greece and Prince Michael of Kent.

Left to right (centre row): Jonathan Shakerley, Princess Beatrix of Holland, Princess Margaret, the Duchess of Westminster, Her Majesty the Queen, the Earl of Burlington, Queen Elizabeth the Queen Mother, Princess Anne of Denmark, Queen Anne-Marie of Greece, Princess Benedikte of Denmark, Nicholas Shakerley.

Left to right (front row): Miss Amanda Leigh, Lady Tara Creighton, Michael James Campbell, the Hon Selina Weld-Forrester, Viscount Strabane, Lady Laura Campbell and Lady Sarah Armstrong-Jones.

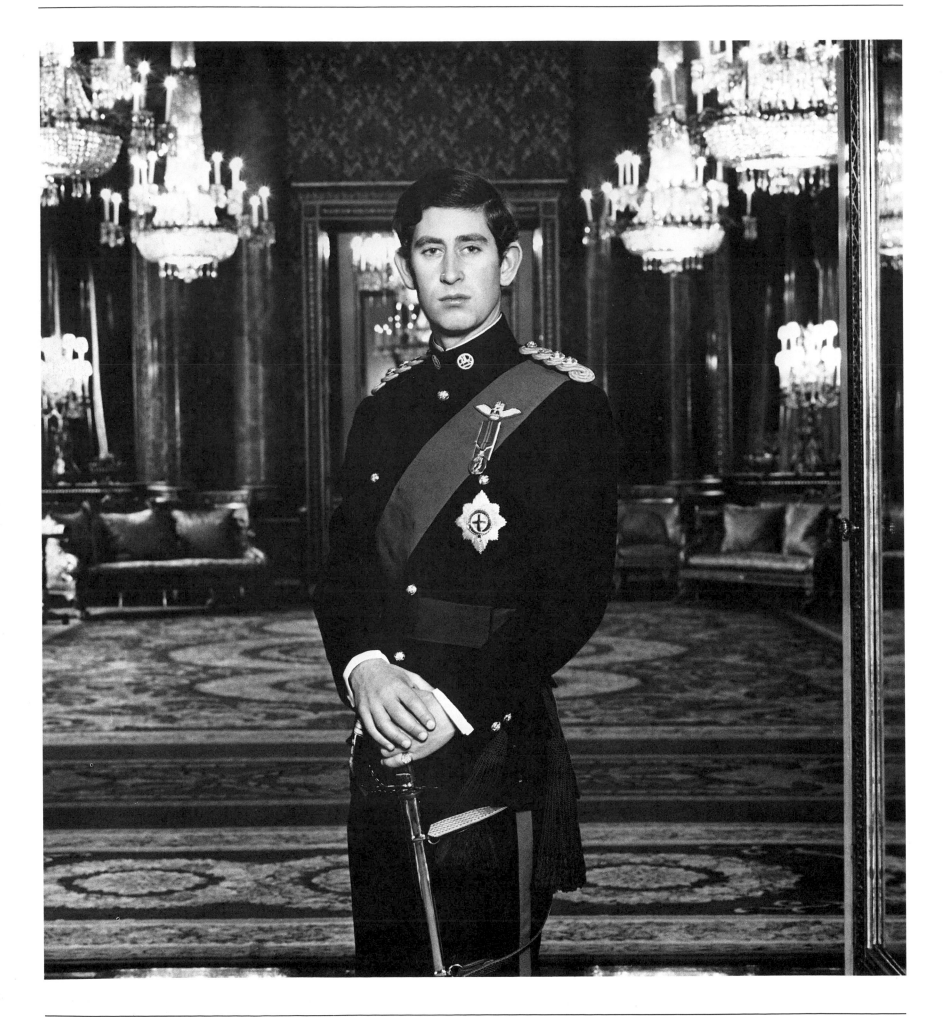

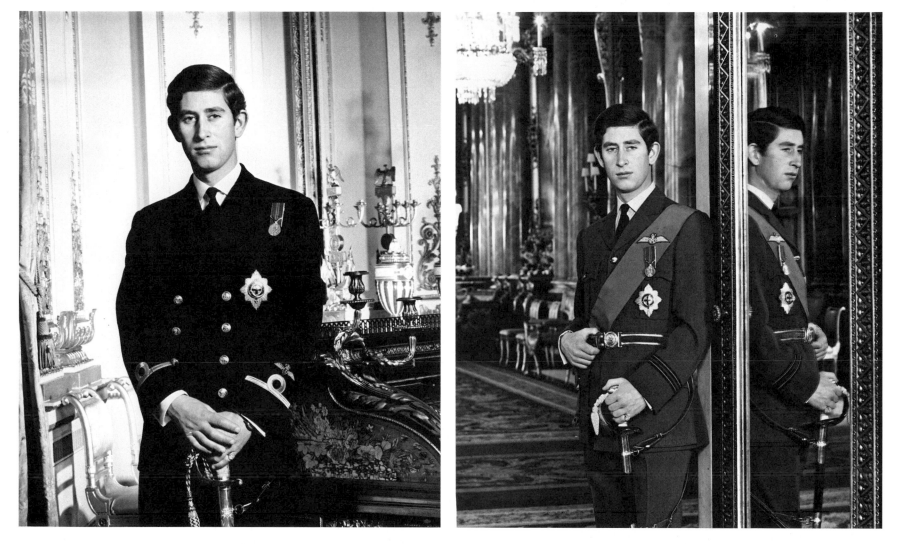

Prince Charles photographed in various uniforms of the army, navy and airforce, taken at Buckingham Palace.

*A*s I have discovered in the past Princess Anne is another member of the royal family who is best photographed in surroundings with which she is familiar. So when I was commissioned to take her portrait for St John Ambulance I decided on Buckingham Palace as the venue.

I was particularly pleased to be asked to do the photograph because I am county president of St John Ambulance in Staffordshire and have a great admiration for the organisation. The Princess had just become Commandant-in-Chief, Ambulance and Nursing Cadets.

I have found that the combination of a uniform and a plain background can make for a rather bare, severe-looking picture so after examining various State rooms and corridors in the palace, I decided on the Princess's own sitting room. I felt she would be most at home there and, although the background was a bit busy, she seemed to look right in that setting.

One of the things that struck me during that session was just how quickly members of the royal family can change their appearance. The Princess arrived at the Palace for the session wearing a pair of jeans with her long hair flowing behind her looking as if she had just come in from a country ride. And yet, ten minutes later, there she was ready to start the session, in immaculate uniform and with her hair beautifully done.

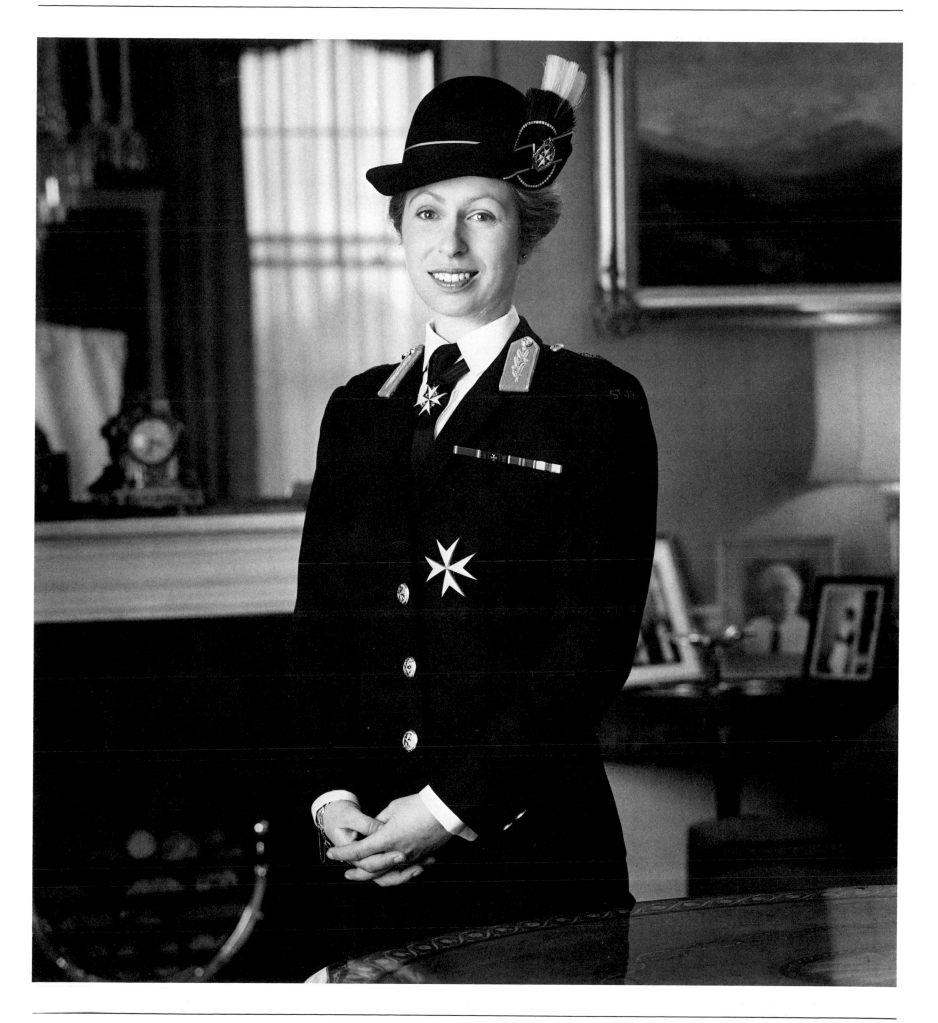

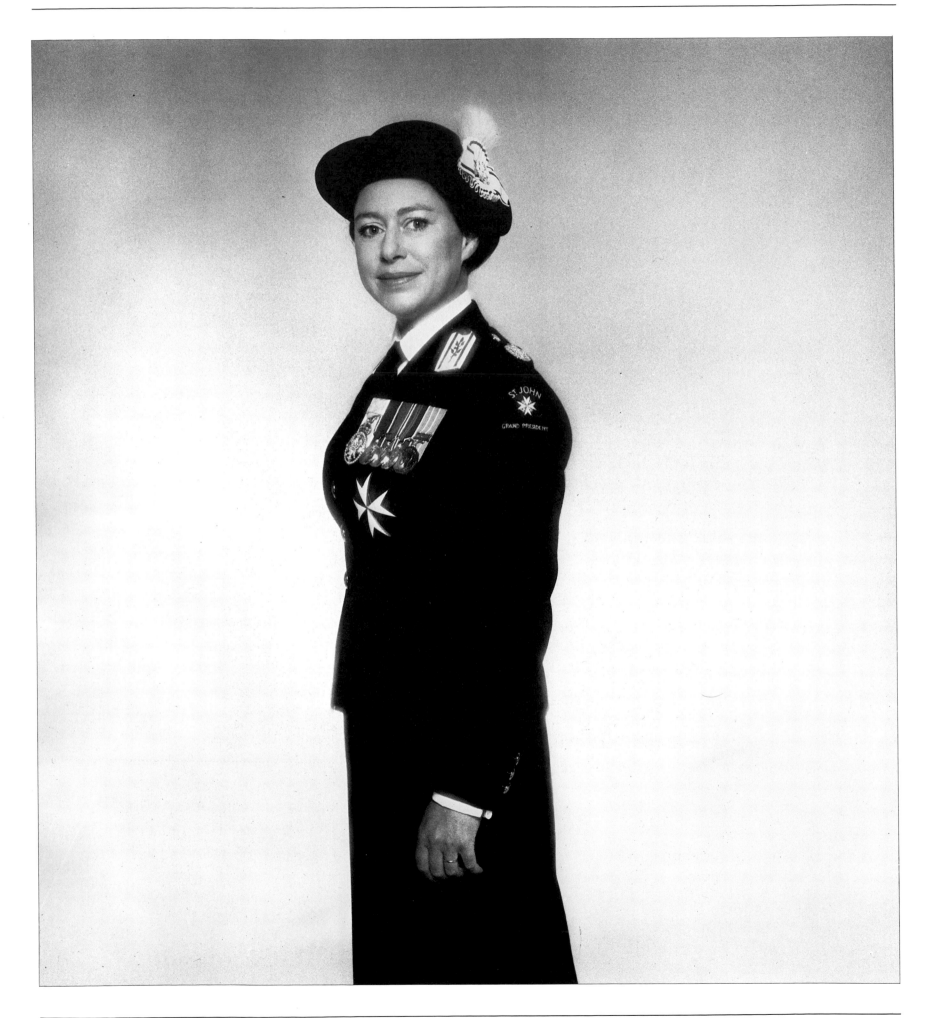

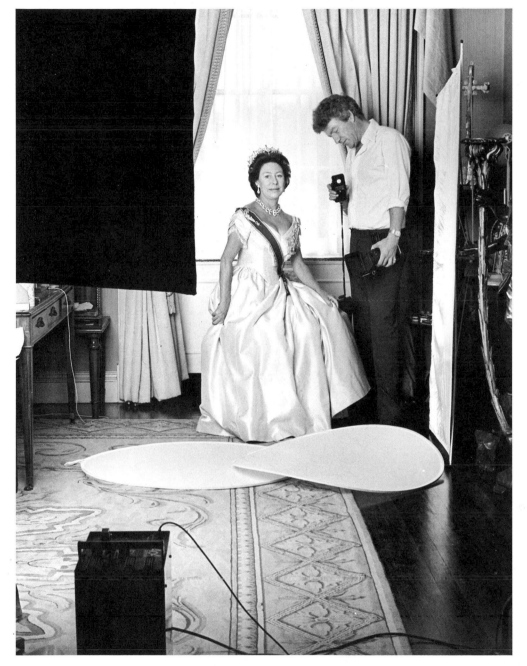

Patrick Lichfield photographing Princess Margaret in 1982.

Opposite: Princess Margaret in the uniform of Grand President of St John Ambulance.

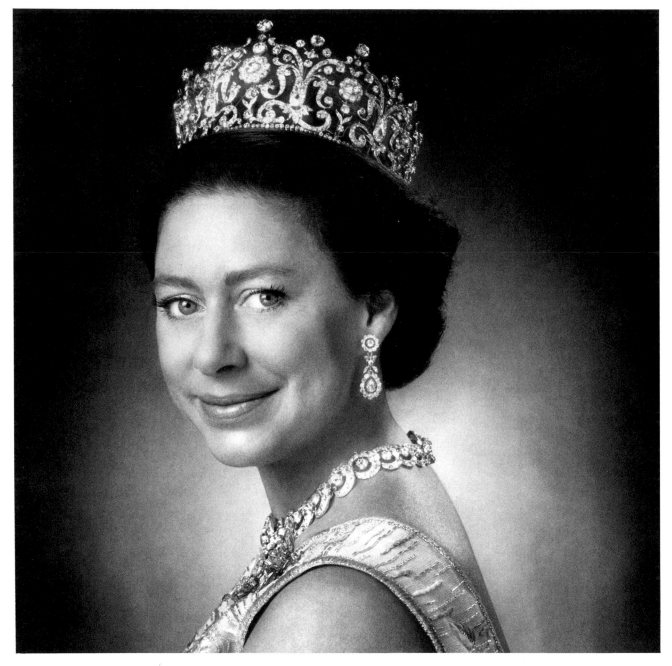

Above: A formal photograph of Princess Margaret taken in the studio in 1973.

THE WEDDING OF
HRH THE PRINCE OF WALES
AND THE
LADY DIANA SPENCER

I had to move very fast on royal wedding day last year. I had already taken many photographs and the balcony appearances and the formal photographic session had taken longer than expected. It was imperative, however, to get a good crisp shot of the Prince and Princess of Wales for worldwide distribution – a picture that would reproduce well in newspapers and magazines however primitive their printing equipment.

The Queen was becoming worried that they were going to be late for the wedding breakfast and time was running out. I hastily taped the sheet I had requested from the Palace to the wall of the balcony above the Grand Entrance. In the rush no one had time to iron the sheet so the creases had to be carefully erased from the photograph afterwards.

The Throne Room, where I had taken the big group is a bit elaborate for good portrait shots so I deliberately chose a plain background as a way of showing off the bride's dress and making their heads stand out in relief. We went out on to the balcony, which overlooks the Palace quadrangle, and shot just one roll of film which was all there was time for. Considering the hectic rush, I was very fortunate indeed that the photograph turned out so well.

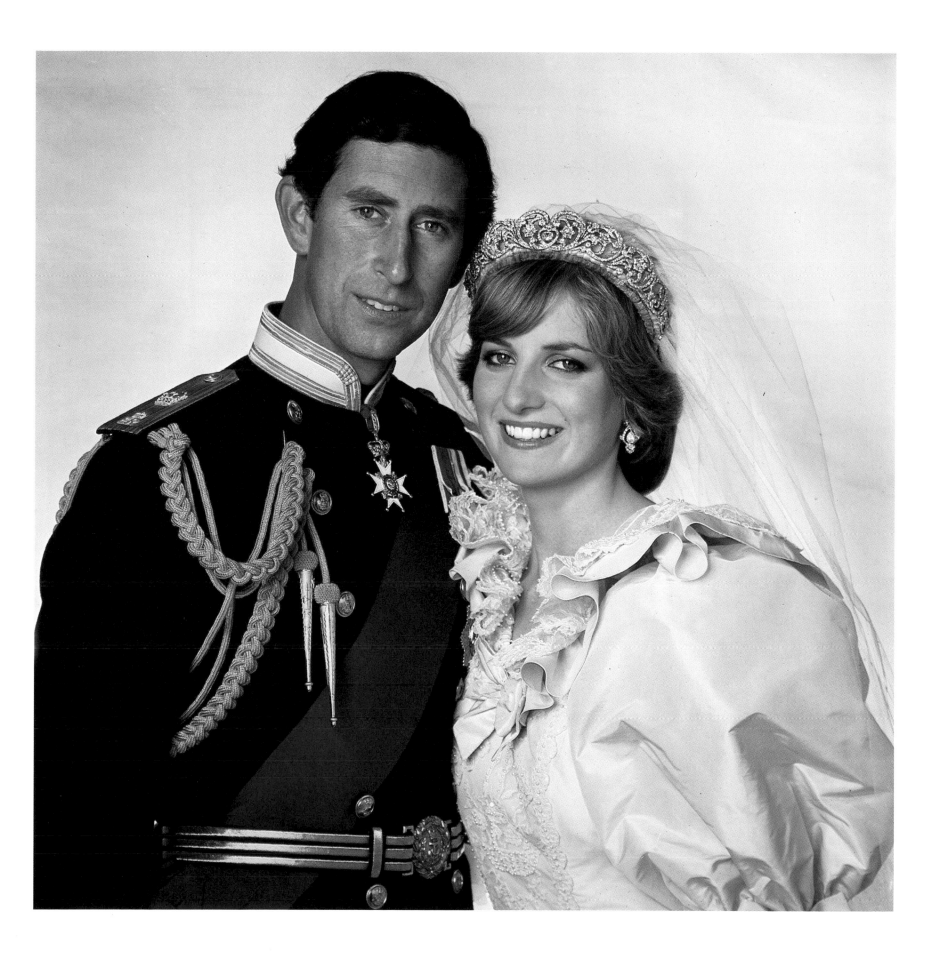

Immediately after disembarking at Buckingham Palace, having returned from St Paul's, members of the royal family made their way to the Grand Entrance. Princess Margaret paused to wave.

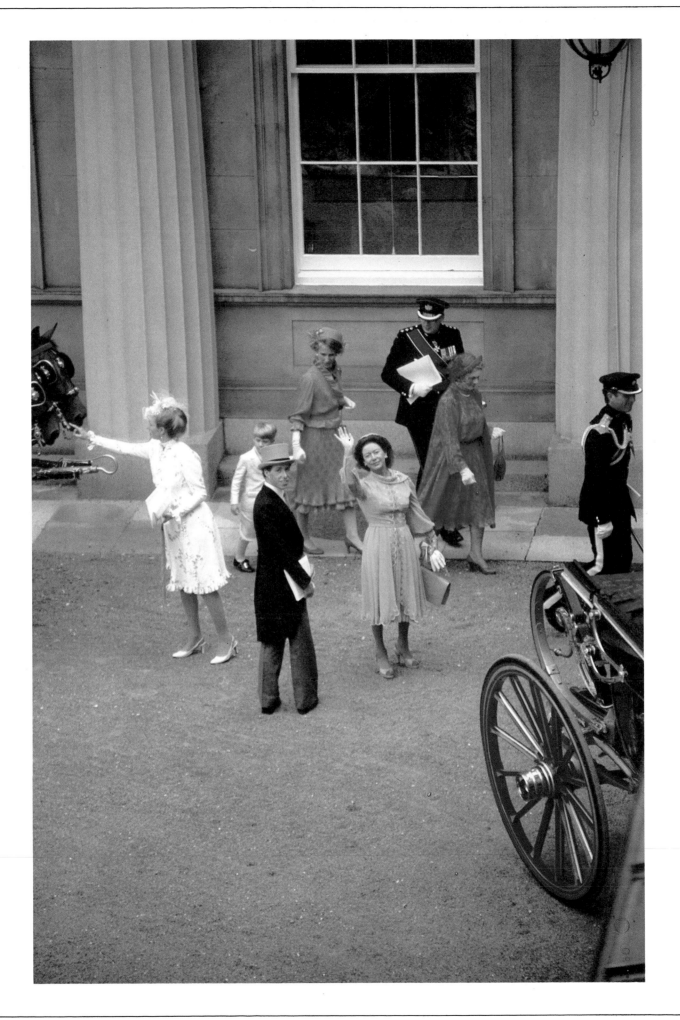

*A*t lunch, after I had taken the photographs of Miss Zara Phillips' christening, Prince Philip gave me a piece of advice that was to prove most useful when I came to tackle the problem of photographing the big group at the royal wedding two days later.

I was rather late going in to lunch because I had to clear up my equipment and the only vacant place was at a small table where Prince Philip was sitting. Not unnaturally, the conversation turned to the imminent wedding and I asked him how I could possibly manage to line up all the fifty-seven members of the royal family and foreign royalty due to appear in the big wedding group. The Prince replied, 'Oh well, it's not too difficult; the other day when we were in Luxemburg for a wedding they simply gave us name cards to stand on attached to the carpet.'

When lunch was finished, inspired by the idea, I rushed back to the studio and started planning the group photograph. There was not time to make out individual name tags for everyone so we just put numbers down on the steps where the shot was to be taken. We then compiled a list of all the names beside the appropriate numbers. The Queen amused us all when she came in to the Throne Room and complained that she could not find her own name. Naturally, as she was to be in the centre, we had not given her a number.

As there had been a party at Buckingham Palace two days before the wedding, we only managed to get into the Throne Room the afternoon before the ceremony. We had several rehearsals to make sure everything was correctly set up, with my assistants trying to simulate being fifty-seven people. They had bought little masks of Prince Charles and Lady Diana Spencer which were on sale at every street corner and they posed gamely as I practised the shots. Later we developed these test photographs to ensure that the real thing would be a hundred per cent technically sound.

The Throne Room is rather too red for good photography so we laid down a great number of white sheets in the hope that they would reflect the lights. It is, however, a marvellous room for a dramatic photograph with the impressive back-drop and the canopy above the throne.

Trying to work out who stands where in a big group photograph can be quite a problem. Firstly, in order to avoid continuous rearrangement during the session, it has to be planned so that people can be peeled away gradually, until only the close relations are left, and then, finally, the bride and bridegroom. Thus, more distant relations are on the edge of the group, and the nearest relations towards the middle. Then there is height to take into account. Some of the younger members of the family would have been better in the front row but that was impossible because of the order of precedence. However small they were, though, it was essential that they could see the camera.

It can be imagined that, when the time came, it took some time to arrange everyone in the correct spot. As the minutes passed, those who had been placed in position first were, if not becoming restless, certainly getting talkative. I had anticipated this might happen and taken the precaution of bringing a small whistle with me.

It would have been useless trying to issue verbal instructions. The photographers were at such a distance from the group that a sergeant major, even with his stentorian voice, would have had difficulty marshalling them. Earlier, looking through the Palace archives at pictures of similar occasions, I could not find a single photograph where everbody was looking at the camera with an attractive expression. So I resorted to a whistle which I blew loudly when I needed them all to look into the lens at the same moment. I had never used the technique before but it seemed to work, particularly with the children who can cause problems in such a big group.

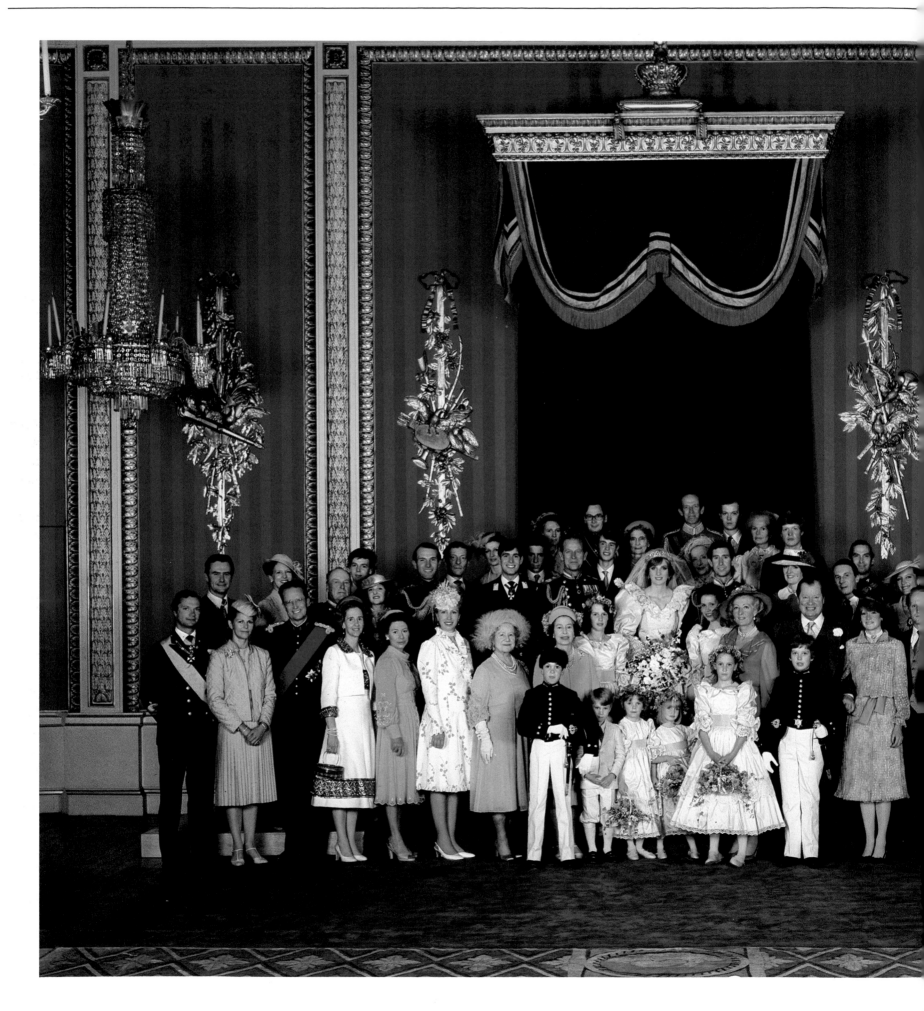

This photograph was essential as an historical record but, in some ways, it was the least interesting wedding picture of them all even though it took so much hard work to set up.

Front row, left to right: Edward van Cutsem; the Earl of Ulster; Catherine Cameron; Clementine Hambro; Sarah-Jane Gaselee; Lord Nicholas Windsor.

Second row: King Carl Gustav and Queen Silvia of Sweden; King Baudouin and Queen Fabiola of Belgium; Princess Margaret; Princess Anne; the Queen Mother; Her Majesty the Queen; India Hicks; Lady Sarah Armstrong-Jones; the Hon Mrs Shand Kydd; Earl Spencer; Lady Sarah McCorquodale; Neil McCorquodale; Queen Beatrix of the Netherlands; Lady Helen Windsor; Grand Duke Jean and Grand Duchess Josephine Charlotte of Luxembourg.

Third row: the Prince of Denmark; Queen Margrethe of Denmark; King Olav of Norway; James and Marina Ogilvy; Captain Mark Phillips; the Hon Angus Ogilvy; Princess Alexandra; Prince Andrew; Viscount Linley; the Duchess of Gloucester; Prince Philip; the Duke of Gloucester; Prince Edward; Princess Alice; the Princess of Wales; Ruth, Lady Fermoy; the Prince of Wales; the Duke of Kent (behind Lady Fermoy); the Earl of St Andrews (behind the Prince of Wales); the Duchess of Kent; Lady Jane Fellowes; behind her Viscount Althorp; Robert Fellowes; Prince Michael of Kent; Princess Michael of Kent; Princess Grace of Monaco; Prince Albert, Hereditary Prince of Monaco; immediately below him, Prince Claus of the Netherlands; Princess Gina and Prince Franz Josef of Liechtenstein.

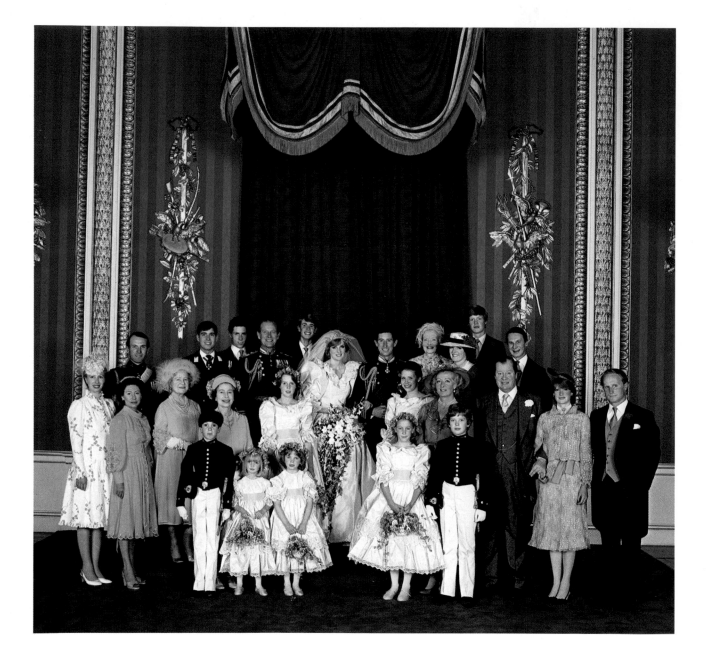

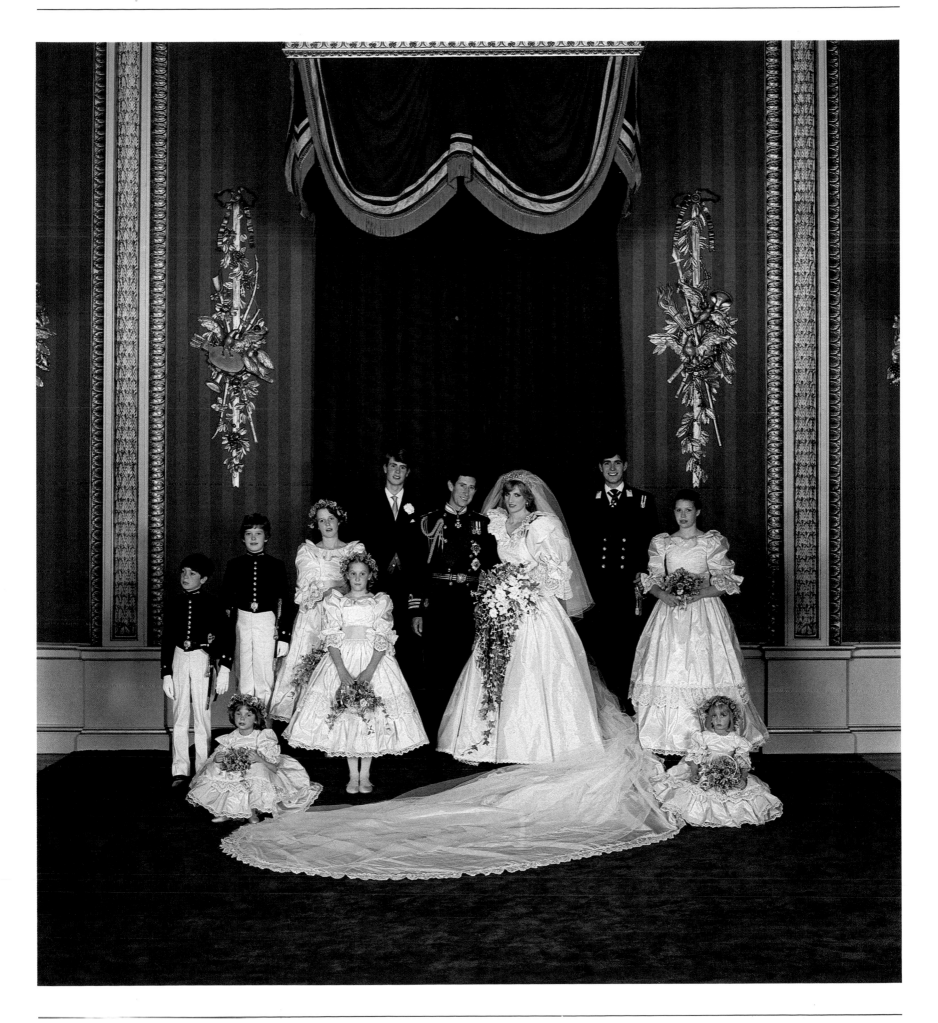

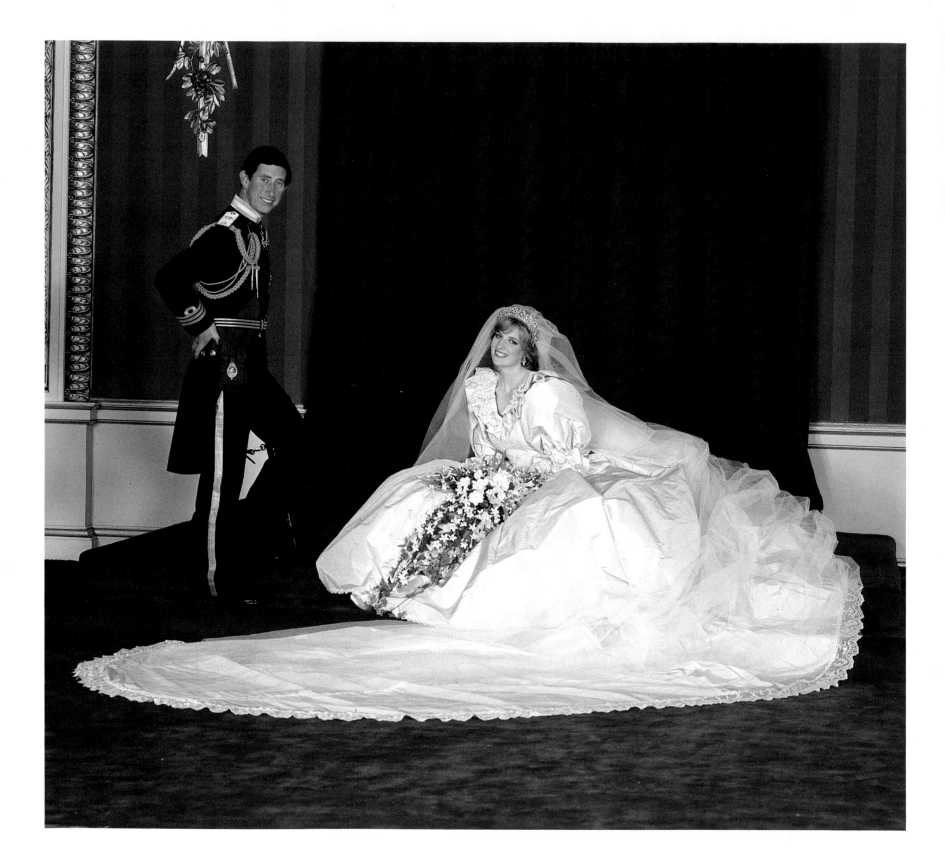

An unusual photograph of bride and groom taken directly after the formal group photographs. It is rare to picture a bride seated like this but the Princess of Wales's dress made a marvellous frame for such a pose.

*W*hen I had taken the shots of the Prince and Princess of Wales together on the balcony above the Grand Entrance I had only seconds to spare before everyone had to go to the wedding breakfast. So with enormous haste I took just three photographs of the Princess alone, taken through a small aperture called a vignette placed over the lens of the camera. The effect was to play down her elaborate dress and make her face the focal point of the image.

This balcony is particularly good for daylight shots as it is shaded by a portico. Princess Margaret and Lord Snowdon were photographed there on their wedding day in 1960 by Cecil Beaton – Lord Snowdon even holding the reflector to help.

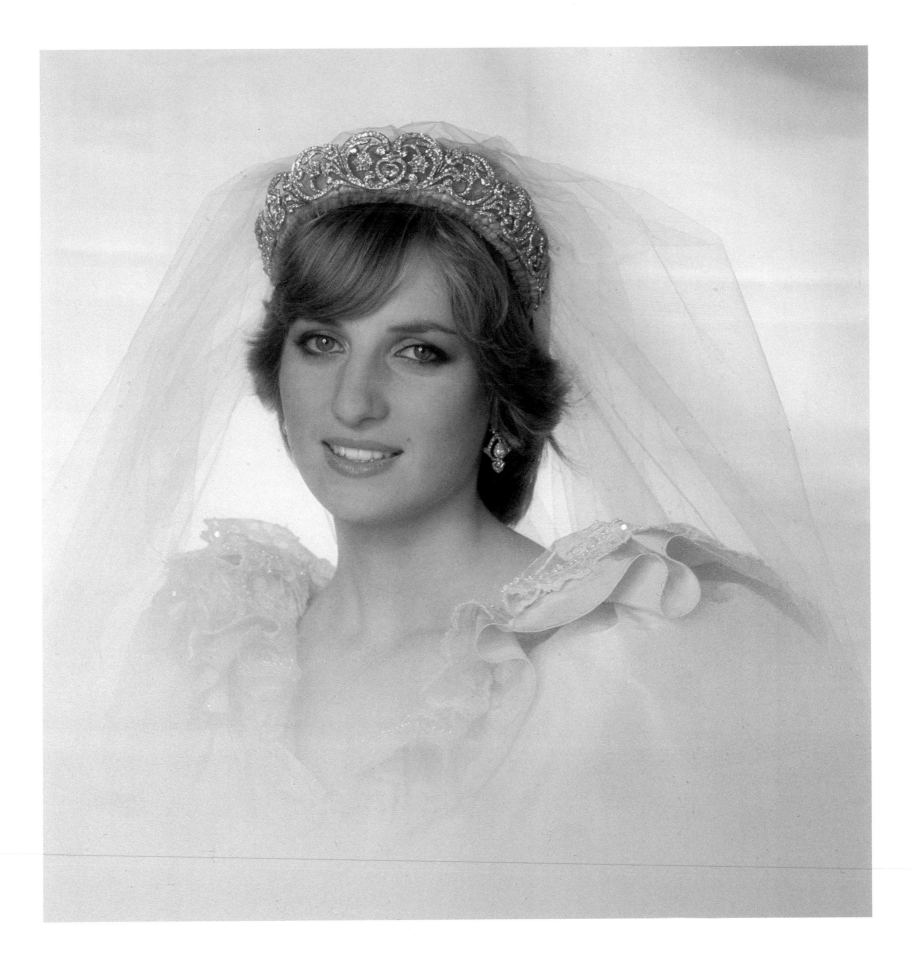